Visions of Illinois

A series of publications portraying the rich heritage
of the state through historical and contemporary
works in photography and art

Prairiescapes
Photographs by Larry Kanfer

Nelson Algren's Chicago
Photographs by Art Shay

Stopping By: Portraits from Small Towns
Photographs by Raymond Bial

Stopping By

Stopping By
Portraits from Small Towns

Photographs by Raymond Bial

with a Foreword by Robert Bray

University of Illinois Press

Urbana and Chicago

Publication of this work was supported in part by grants from
the Illinois Humanities Council and the Joyce Foundation.

This book is printed on acid-free paper.

Library of Congress Cataloging-in-Publication Data

Bial, Raymond.
 Stopping by : portraits from small towns / photographs by
Raymond Bial ; with a foreword by Robert Bray.
 p. cm.—(Visions of Illinois)
 ISBN 0-252-01587-8 (alk. paper)
 1. City and town life—Illinois—Pictorial works. 2. Illinois—
Biography—Portraits. 3. Illinois—Social life and customs—
Pictorial works. I. Title. II. Series.
F542.B53 1988 88-17407
977.3—dc19 CIP

To my mother,

who took such pleasure in other people,

and to Linda,

who has helped me apply that sentiment
to my work.

Foreword

The people in Ray Bial's pictures come from places like Broadlands, Cerro Gordo, Ivesdale, Moonshine, Toulon. These are the sort of downstate Illinois towns whose quaint names mask their marginality: some of them don't even count as dots on the official state highway map, which means you have to know where you're going to find, say, Oilfield on a Sunday drive. The largest of Bial's towns, Chillicothe and Villa Grove, for instance, still sustain nostalgic small-town institutions—barbershops, where nobody seems to need a haircut and everybody can afford one, persisting in an age of hairdressers (pl. 58); or movie houses still showing shows, though hardly the features-with-cartoons of bygone days (pl. 10). The smallest (and far more typical) comprise a railroad spur with a high-rise grain elevator alongside (dominating the landscape the way it dominates the local economy: as the Co-op goes, so goes Cisco); a filling station, grocery, and café; maybe a post office and tavern if these wide places in the road are wide enough. That's all there is, and less of it every year. The demographic truth is starkly simple: these towns are dying. They and their railroad tracks are being abandoned, gradually but at a quickening rate, becoming so many deserted villages, ghost towns, ex-Podunks; their old settlers and businesses dying; the young leaving for wherever work and life will happen to flourish in the year 2000.

Of course, there's nothing historically unique about this: young America has been moving from farm to town, town to city for more than a century ("How ya gonna keep 'em down on the farm after they've seen the farm?"). During our nation's history of economic ups and downs, farms and their supporting towns have suffered. From the Great Depression to Populism to the Panic of 1837—this takes us back 150 years, or nearly the whole civilized existence of Illinois as a state. But always in the past the country and its villages survived; only sentimentalists or alarmists predicted the end of rural traditions. Now, however, the contemporary exodus has a feeling of finality—at least to someone living close to it. Who has ever seen a terminal town reborn? Was there ever an asphalt prairie parking lot torn up to make renewed farm acreage?

No, this time the cultural movement is strictly one-way: into "regional cities" such as Bloomington or Champaign, towns themselves "only yesterday" but now metropolitan by almost any standard, not islands but rapidly expanding continents in the corn. And this points up two important differences between the old and new emigrations. First, this one is not a sudden displacement based on economic depression. Rather, it's a slow and inexorable movement *away* from rural life that appears to be independent of the bumps and burps of the economic cycle. Second, unlike earlier removals, the technology of communications and transportation have obviated the need to break social and family ties. When Dreiser's "Sister Carrie" Meeber took the train for Chicago before the turn of the century, she was leaving "Columbia City" for good, neither wanting nor expecting to return. The way back to that dubious prairie Eden closed forever behind her, as seamlessly as water around a sinking stone.

Chicago was not only distant from home, but alien. Montreal and New York were much more so. No wonder that moving to the "evil big city" involved rites of initiation and fundamental rebirth. But now the regional cities are nearby and made even nearer by cars—or motorcycles or small pickups. You can live in Champaign and still be only minutes away from Mom and Dad in Philo or Grandma in Villa Grove. Moreover, the *cultural* distance has significantly narrowed. Philo and Villa Grove are *already* in Champaign's orbit, comfortably so, and these days Colfax kids get their BMX bikes, their sneakers and cool clothes, at one of Bloomington's shopping malls. Parents drive the twenty-plus miles each way, and parents pay the high price of TV consumerism. Back home, the kids watch their racing heroes jump dirt moguls on cable, then ride downtown and line up happily for the camera in front of the local five-and-dime—the one where they never buy anything bigger than pop, candy, yo-yos. Posed proud, straddling some very expensive bikes, they are boyishly oblivious to a profusion of signs on the windows behind them, announcing the store's imminent closing (pl. 17). Bloomingtonians may

feel nostalgic about the country, come out for a Friday night meal at Fincham's Steak House, but the people of Colfax (pop. 920, in the McLean County outback) daily stretch their necks toward that western horizon: Illinois 165 jogging to the city may not be the yellow brick road, but on the clear days damned if it don't look like the new Oz is growing right out to meet them!

The urbanization of everything everywhere—in this case the small-town civic business of going out of business—provides an ironic backdrop to some of the portraits in *Stopping By,* as if the photographer, to make a point about time and change, social and human, had purposely hung a faded canvas of peeling paint and moldering masonry behind his subjects. This effect can be striking: a farmer in uniform (cap, plain dark shirt with sleeves rolled up to the elbows, overalls and ballpoint pen) stands like a relict amidst ruins—a long-shut hardware store with tongue-and-groove wooden ceiling, ornamental pilasters, and doors twice as high as a man, where Monogram furnaces and Chief paints were sold for seventy years; now the makings of a rummage sale, antique pram and milk bottles likely to bring good prices from city collectors. A sign on the window says village clean-up next Saturday, May 3rd. But such hard wear is long beyond repair, even with Old Dutch cleanser in New Holland, Logan County, Illinois (pl. 56).

While subtle ironies of context occur throughout *Stopping By,* the book is essentially about people. While we frequently see Bial's folks *in* their customary places—social or vocational—seldom do scenes outscale humans or cluttered contexts absorb individual character. Indeed, as a rule, the most successful photographs are those with minimal context, abstracting from the material culture to give compositional support and symbolic resonance to the portraits. Over many weekends Bial drove the blue highways and followed the rails across the middle of the state, deliberately seeking those who were left (some left behind) in the marginal towns. Then, in the time-honored itinerant way, he would drag out his big Mamiya portrait camera (never off its tripod) and offer them his

version of photographic immortality. Bial's eye is sincere, like his personality, and for this reason the portraits are generally open to the camera—for the most part neither revelatory nor mysterious (with important exceptions) but rather genuine and public, reflecting how the subjects don't mind being seen but without elaborate "get-ups" or formal poses. Bial achieved this familiarity by first establishing rapport and then catching his people in "natural" stances. Not everyone cooperated: there are occasionally standoffish, guarded, even defensive attitudes (this is particularly true among the middle-aged portraits), but mainly the subjects trusted the photographer not to make sociological or artistic examples of them.

Some of the most open and friendly countenances in *Stopping By* belong to the gallery of small-time "owner-operators" and public officials. Among the latter is Denny Kresin (pl. 4), a "road commissioner" (who looks anything but official) sitting, cap and overalls, at a table in the Allerton Café. His eyes, his slightly turned head, his bulk—all suggest much more than asphalt and potholes: the possibility of whimsy, like Jonathan Winters doing a John Deere commercial. Or consider R. Duane Bowdre, the Barber of Bement (pl. 7). *"Sono il factotum della citta?"* Well, probably no one is all that busy in Bement, but Bowdre does look like a capable and politic barber nonetheless. Apparently between customers, he stands slightly left-of-center, hands on a newish barber chair, back mirrored, his face wearing an expression of fixed affability, his body wearing a dark polyester barber's shirt with the inevitable white cigarette pack poking out of the pocket. Surrounded by the paraphernalia of his profession, Bowdre projects a conventional, confident welcome to his shop, where haircuts are three-fifty and have been since February of '84. This composition could be an advertisement, and an effective one—until we notice the real hair on the floor.

An older generation of barber is represented by C. F. Schumacher of Cerro Gordo (pl. 9), though we wouldn't know his work except from the caption. For this marvelous seated portrait is completely without

vocational context. The folded hands, clean and agile and aged, might be a clue, but here job and place are irrelevant once we fasten onto the dignity of Schumacher's face, the humor and wisdom of his eyes. Hands and eyes are traditional indicators of character, and here as elsewhere Bial pays them close attention. Schumacher sits with legs crossed on a wooden chair, angling a bit to make space in the room. A suffusing painterly light models him from the left, until every pill of his fabulously worn sweater stands out and the right half of his face deepens into shadow. Details of the room are severely limited: baseboard, door jamb, and a wall painted with whorls like Van Gogh brushstrokes. The context is decayed, like the sitter himself, but his character transcends the bleak environment.

Wisdom may be too strong a word for the evocation here. Yet nothing else seems to catch the furtive quality of revelation that distinguishes the very best photographs of *Stopping By*. We see it again—this time a cowboy kind of wisdom, the Marlboro Man with soul—in Clifford Davis, elevator superintendant at Cisco Co-op Grain (pl. 13). He stands in half-portrait, head cocked, against the concrete of the elevator, which makes a subdued contribution to the dialectic of rough and smooth, light and dark, playing over the human figure. Davis wears an immaculate and soft uniform shirt; he has a worker's neck and lined forehead; he sports a moustache with the rest of his face unshaven, at least on this particular morning. The supremely clear eyes, however, are what our own eyes keep coming back to. Their close focus is on daily experience, lots of it and not always of the best; their far-off look includes the possibility of a more heroic pain, the hope that somewhere myths still live and someone named Cliff Davis might live in them.

Later in the book Bial brilliantly differentiates the generations through a parallel portrait of a much younger man: William R. Orendorff, Jr., an employee at the Grand Prairie elevator in Philo (pl. 63). Orendorff is *doing* the same thing as Davis but *being* radically other. From extroverted action to quiet interiority: no agribusiness cap this time, no shiny

namepatch on a uniform shirt, just whitened blue jeans and a soft work frock which very carefully does *not* obscure his Harley-Davidson tee shirt with its dramatic eagle-icon (we all think we know what *that* means: roadhouse blues nights and weekends). Everything about young Orendorff looks fastidious, from his neat, casual clothes on up to the dust-mask around his neck (please, no industrial diseases or hayseeds stuck in the teeth of this generation!) and the androgynous face and head—styled hair, Miami-vicious beard, translucent skin. Intense and narrowed eyes stare out of a square head, a nineteenth-century throwback; Orendorff's eyes recall those in Daguerreotypes that seem to gaze inward and out at the same time. These are eyes just beginning to see, and Orendorff is keeping the vision private. Someday Bial's camera might return to coax out who William R. Orendorff is, but not yet. Look closely at his shadowed ear: there's an earring. Do we really think we know what *that* means?

The town of Elliott (pop. 370) is in southern Ford County, five miles east of Gibson City on Route 9. When Ray Bial "stopped by" Elliott on September 12, 1987, he was doing his usual weekend scouting for subjects, expectations probably no better than average as he pulled into town. But from that brief encounter emerged four of the finest photographs in the collection, capturing four of the most memorable characters among the eighty-five. For convenience we can refer to them as the "Elliott Group" (pls. 25–28).

The first image (pl. 25) is deceptively simple: only six objects in the entire composition, three of them animate, two of them men. John M. Hatteberg and Harold Jones, both looking like retirees, sit outside in the sun on a wooden bench; behind them is an unbroken wall of dark, rough-hewn panelling;; in front, a concrete sidewalk. Jones, relaxed and slouching, curbs his dog, a black and white mutt peering off to the left at something out of the picture. The space between the men indicates a mild degree of acquaintance, yet from dress and physiognomy we might assume they were affiliated. We get this notion not just from a general

facial likeness, but also from their identical caps and very similar glasses, features which accentuate the irony of their very different poses. Jones's head and bill are slightly down, shading his face; his lenses are dark, and we can scarcely see the eyes behind them, though he seems to be looking directly at the camera. On the other hand, Hatteberg, like Jones's dog, isn't having any: stiff and upright in posture, arms defensively infolded, he looks askant, perhaps at whatever the dog is also finding interesting, perhaps just to show a modicum of mistrust. The Hatteberg-mutt-Jones ensemble is intriguing, disturbing, and highly sculptural—like something out of a wax museum or, in more artsy terms, like those super-real epoxy tableaux by Duane Hansen that fool us when we suddenly come upon them in galleries.

We can easily imagine that the two old men are taking the sun outside Janet Brewer's café. Meanwhile, the proprietress is inside posing for an "owner-operator" vocational portrait (pl. 26). Hers is a clean, well-lighted place (and face), softened by curtain-filtered daylight. But the café is curiously empty: rows of neatly-stacked coffee cups, yet the coffee's not on; a spotless and shining counter, yet no pie in the pastry cases. Maybe breakfast is over and lunch isn't served on Saturdays. In any case, Janet Brewer makes an expansive but somehow classically restrained gesture with her hands on the counter, simultaneously welcome and benediction, as if to say to camera and clientele alike, "It's mine, and I accept both the power and responsibility of ownership."

Back outside, a man with the same last name (Janet's husband?) has been working long and hard enough to get dirty (pl. 27). Daryl Brewer, unabashed hog farmer, lets the camera catch him as he is: a compact, powerfully built man in a work-stained Illini tee shirt that's as faded as the "Rose Bowl Fever" it celebrates. Brewer stands out from a hypnotic background of dark brick and light mortar. The sharp V-bill of his cap is repeated by his squinting eyes and the wimpling flesh of cheeks and chin. His short, muscular arms hang loosely down; his hands, obviously used to grasping, are still half-clutched, with thick white thumbnails and a kind of worker's stigmata on the back of the left one.

If Daryl Brewer represents Elliott's world of work, then life after work is wonderfully captured in the juxtaposed portrait of Roscoe Harding, retired from the railroad and looking immaculate in his leisure (pl. 28). Harding also stands in front of a brick wall, monotonously dark this time, and frankly faces the camera. But he seems to take up more space than Brewer, probably because the large circle made by his rounded shoulders, curving hands, and white dotted shirt—notice the nice detail of the pinned collar—is so compositionally right. The face is remarkably "old world" and beautifully modeled in the uncertain light (the *shirt* itself seems to provide illumination). He has predominate ears, a well-groomed handlebar moustache beneath the nose and deeply-etched, dimpled cheeks, and storybook beetling brows—overhanging deep caves for eyes but no evidence of eyes themselves. So we look to the hands: clean, strong yet delicate, and the left one holding (of all things) an unopened Three Musketeers. Were this Harding's private joke, surely his eyes would tell us. But without the clue of the eyes we are puzzled by this new and unexpected icon—D'Artagnan and company memorialized in a candy bar which for some reason is now being prominently displayed to the camera by one Roscoe Harding, railroad retiree, citizen of Elliott, Illinois. What on earth can it mean? This old chevalier's adventures long over? Sentimental stuff and nonsense! But just suppose such a wild fancy credible: it only makes us more curious about what his railroading life was like, about how retirement suits him. Again, the eyes don't help us, and for once even the hands are silent. As in an emblematic Renaissance portrait, we must try to read the iconography and then take our best guess concerning character, prepared to be dead wrong. On his belt Harding wears a *key-safe*—an "Okay Key-Safe" to be exact—from which is suspended . . . a clip and nothing else. No keys. One would assume that key-safes are rather antiquated; Harding, however, holds to tradition, snapping his on empty of a morning before sallying out to buy a Three Musketeers. They took his set of keys away: he continues the habit of keeping safe

what's gone. Almost by accident, then, the photograph lets us infer something of both Roscoe Harding's status and his state.

The artistic authority and coherence of the "Elliott Group" can be found elsewhere in *Stopping By*. Every single image among the eighty-five is well worth analysis, and most of the pictures will repay close study with increased expressive power. But as we turn the pages of *Stopping By*, there is also a cumulative emotional and intellectual effect, a kind of dioramic scrolling along the ethical continuum of individual-regional-universal in small-town Illinois. Here's a brief tour in fast-forward mode of some of the other striking portraits:

Two children of Hugo (pl. 34–5): he sitting smugly side-saddle on his unlicensed dirt-bike, ready to make life miserable for parents and neighbors; she standing with a would-be big-girl look made futile by a county-fair-princess little-girl pose; his hair still as velour-soft as a stuffed animal's; hers already fuzzy-permed to go with the earrings and lipstick; together, they are pictures of innocence losing—today a cowlick boy and a knock-kneed girl, tomorrow Hugo-nots.

Boyd Landgrebe, ex-land-grubber, retired to Lovington (pl. 39): cocked cap, wattled neck, mottled arms and hands—aged strength against the grain of the cane—all reflecting Bial's special eye for the elderly throughout *Stopping By*.

A boy, Mackinaw (pl. 44): he stands, poised and posed, before the curving art moderne glass front of a barber shop; sad in his super-boy-man tee shirt, a far-away look in his eyes.

A farmer on the Prowl (pl. 60): he's ample, he's tanned, he probably doesn't chew Mail Pouch, and the temperature in Oilfield looks to be going up.

Danielle Rae Stewart is cheerleader happy in Saybrook (pl. 74), maybe because it's catfish and t-bone night at the Four Seasons café. Sandy Kirkman, hanging out at Dave's Conoco in Villa Grove (pl. 78), will love the dog more than the puppy. And the boys down in Waynesville

(pl. 83) won't realize, unless they're startled by the memory in college, the geometric beauty of their bikes and bodies that day long ago, when the photographer showed up in town. . . .

By then it will be too late for all but their frowns, fixed in place. So it goes. Ten to one, they won't be settling in Waynesville; indeed, some chance there won't be any Waynesville left to settle in, regardless. The only sure thing in their lives will be change. They will learn that we can be lost at home, rooted in a desert. If change erodes the old rural land-scape, if sink holes swallow the towns, *character* will remain—something universal distilled from the local, something portable, adaptable, Dar-winian. Individually and as a whole, Ray Bial's portraits in *Stopping By* affirm what Wallace Stevens meant when he said that life is an affair of people, not of places. Bial restores men and women, young and old, to their rightful stature as "principal fauna" in the Illinois landscape. It's just as well, too, since the *classical* Illinois landscape, as five generations have known it, is pretty much no longer there. Foolish to think of in-ternalizing rural life without rural ground to stand on? Yes, but necessary. And the people of *Stopping By* can help. Through them we may imagine an enduring "here" made from the "there" that's gone.

Robert Bray

Preface

This selection of portraits has grown out of my regard for the people of the small towns around my home in central Illinois. I began the project in the early spring of 1986, intending to present a composite portrait of small town life in the Midwest, notably in my immediate region. I have concentrated on the more traditional features of small towns—grocery stores, cafés, barbershops, gas stations, movie theaters, and other places where people congregate, not only to conduct business but to visit with friends and neighbors—and on grain elevators, the primary businesses in many of the farm towns in the region. In undertaking the project I visited all towns in central Illinois with populations ranging from under a hundred people to 3,000 people, with emphasis upon the very smallest communities, and I have concentrated upon those towns which have not entirely lost their traditional character.

One cannot drive through the small towns of Illinois without being struck immediately by a sense of loss. Towns are either becoming cities, and in the process losing their unique character, or dying out altogether. In the smallest towns of the region only the grocery stores or cafés remain in communities which once supported eight or ten businesses, including grain elevators, gas stations, and perhaps even movie theaters. While I have tried to depict the positive features of small-town life, implicit in these portraits is a very difficult reality: not only are farms being lost, but an entire rural culture is threatened.

In order to create a broad photoessay I have made representative photographs of people engaged in a variety of occupations, taking special care to include a balanced selection of photographs of children and older people in order to demonstrate the variety of social activity in the small towns of central Illinois. Initially, I intended to concentrate on environmental portraits in cafés, grocery stores, and other businesses which are quickly disappearing in this region. Yet immediately I found myself also deeply concerned with making character studies of individuals.

The people portrayed in these photographs were in every case allowed to present themselves to the camera in a direct, forthright manner,

precisely as I happened upon them. I believe that this method of photography permits a completely honest depiction of individuals and, on a universal level, of humanity in general. In pursuit of interesting images photographers often concentrate upon the more unusual aspects of their subjects, and on occasion they have rightly been accused of exploiting people. Or they have traveled to other regions to photograph exotic subjects. However, in this book I have selected average subjects from a region best known for its tedious landscape and seemingly predictable ways of life because I believe that people are naturally interested in other people and that all people have innate value. And one important feature of still photography is that it allows the viewer to study every aspect of the person portrayed without staring or otherwise being impolite.

Of course, a good portrait requires considerably more than the recording of a human face, even a face which in and of itself may be interesting. In making this series my challenge was to allow people simply to be themselves while being photographed. As the title of the collection indicates, all of these photographs were made in a purposely casual manner so that the people portrayed would not become self-conscious or otherwise present themselves to the camera in an artificial manner.

This objective was not easy to accomplish. Imagine walking into a barbershop, café, or grocery store, a complete stranger, with a large Mamiya RB 67 camera on a tripod slung over your shoulder. While the photographer and camera need not be invisible, they should be pretty much forgotten when the photograph is actually made. In approaching people in these settings I would say, "I'm doing a series of photographs of people in small towns in Illinois, in all walks of life. Would you mind if I took your picture?" Occasionally people would marvel that I could find anything of interest in them and their community, but most often they understood almost instantly. As one woman explained to her husband, "He's making pictures of regular people like us."

Yet even as I understated my method as I spoke with people, I was privately thinking about composition and lighting, making instantaneous

decisions regarding aesthetic and technical matters so that the person being photographed would remain at ease and not begin to wonder just why I was spending so much time making the photograph. Thus, while the manner in which the photographs were made and their appearance in this book may suggest they were made in an off-handed manner, they are the product of careful planning and intense concentration. After a morning of photographing I always came home more exhausted than if I'd been baling hay all day long.

I must say that my work was helped because the people I photographed were already quite comfortable with themselves. Over a hundred times I was told, "You don't want to take my picture. You'll break your camera!" Or after the photographs were made, "Hope you didn't break your camera!" I smiled on each occasion as if it was the first time I'd ever heard the joke, if only because the more I heard it the more charming it became to me. In a larger American society which is increasingly ego-driven, I found the humility implicit in this standard joke to be downright refreshing.

My other major—and perhaps most important—advantage in this project was that I am a native of the region. I might have been a stranger in town and people often did ask, "Where you from?" However, they only wanted to know the specific town I was from and to have a topic for conversation. Having grown up on farms and in small towns in the Midwest, I was already part of them and always will be.

Stopping By

1 | Edgar Ennis, Retired Farmer, Allerton

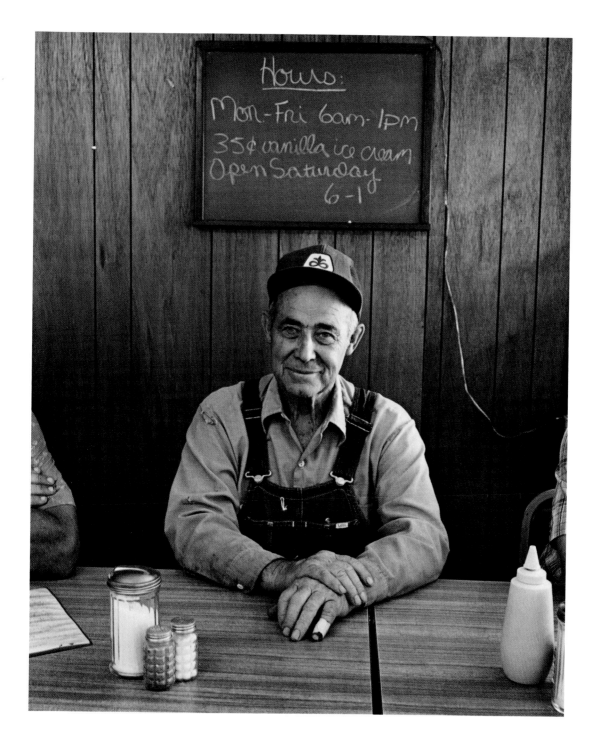

Peggy Jo Downs, Waitress, Allerton

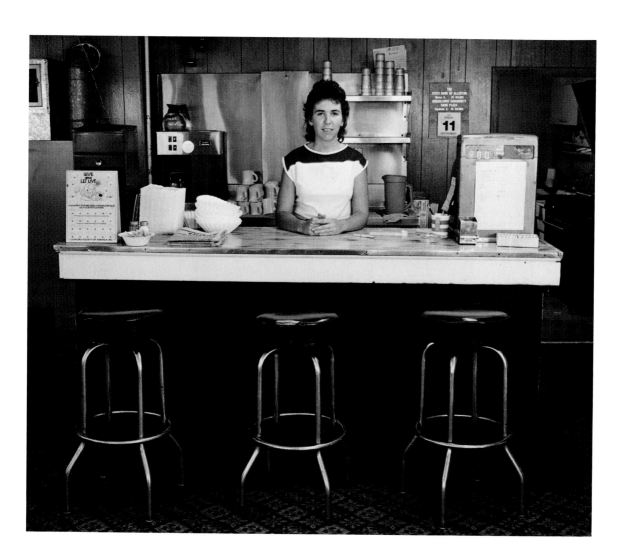

3 | Polly Ennis, Housewife, Allerton

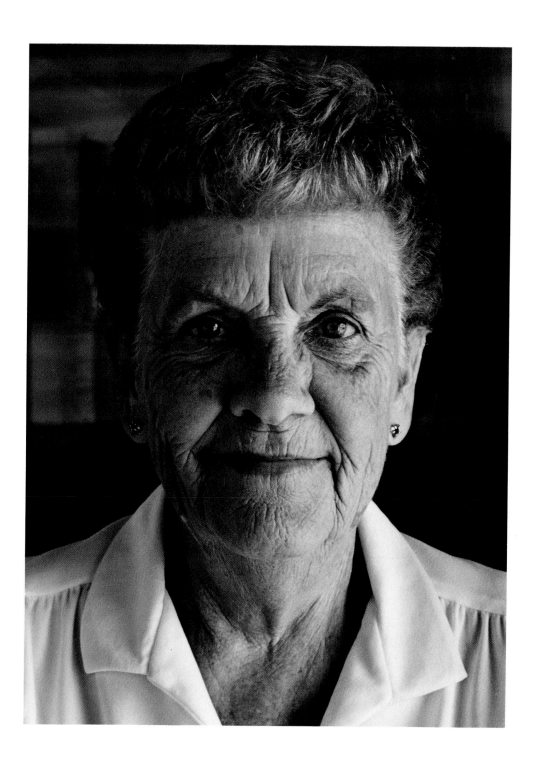

4 | Denny Kresin, Road Commissioner, Allerton

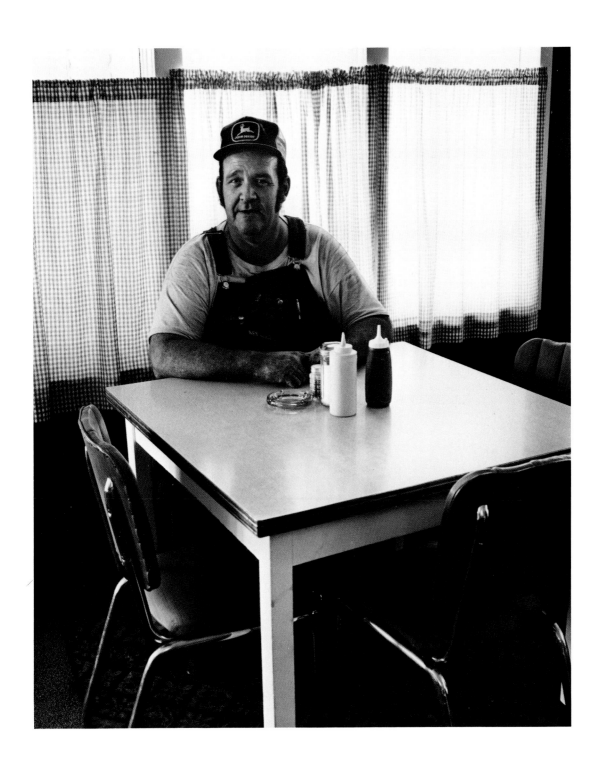

Steve Connor, Beason

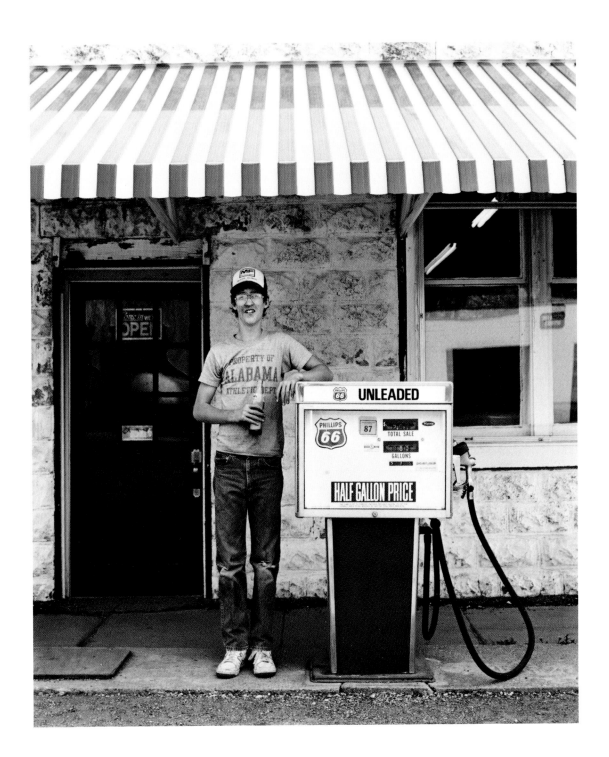

Brad Lowery, Beason

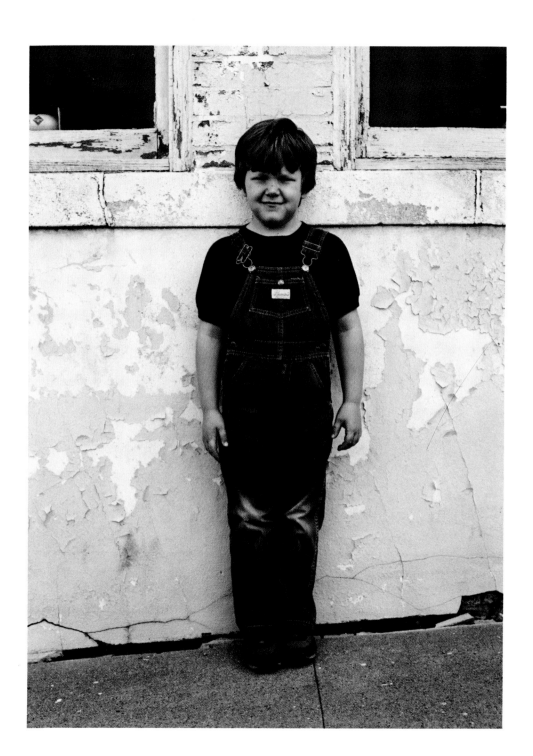

7 | R. Duane Bowdre, Duane's Barbershop, Bement

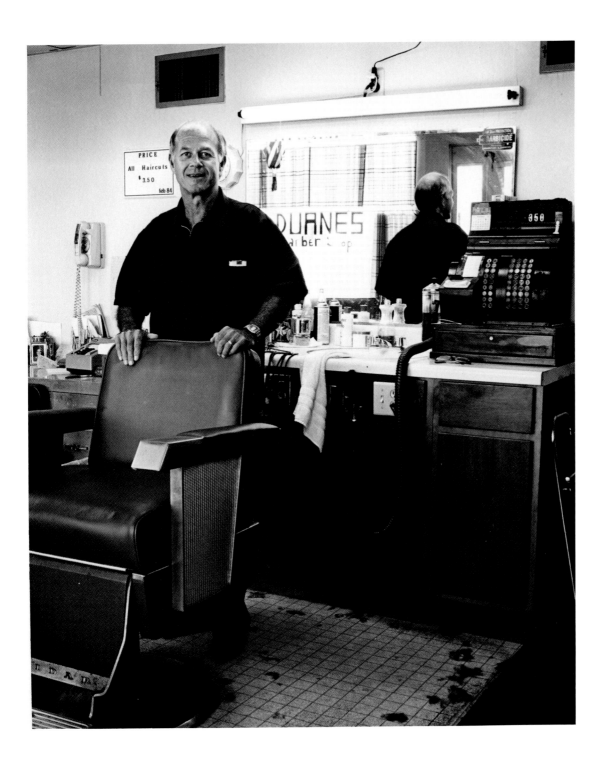

8 | Reinhold Bialeschski, Duane's Barbershop, Bement

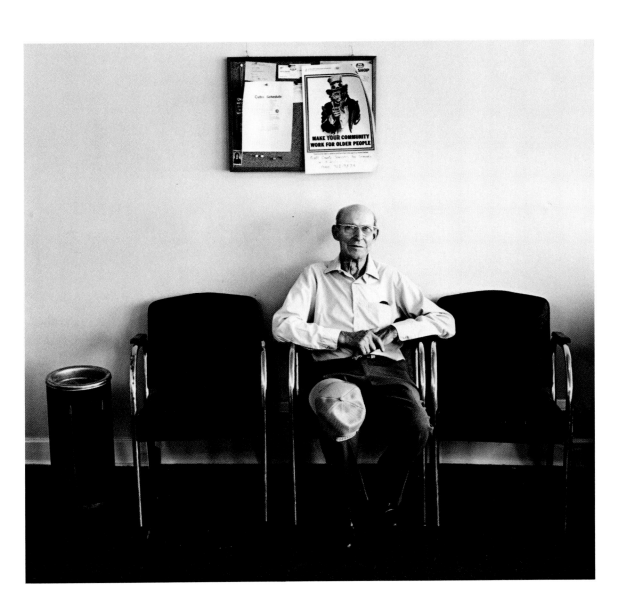

9 | C. F. Schumacher, Barber, Cerro Gordo

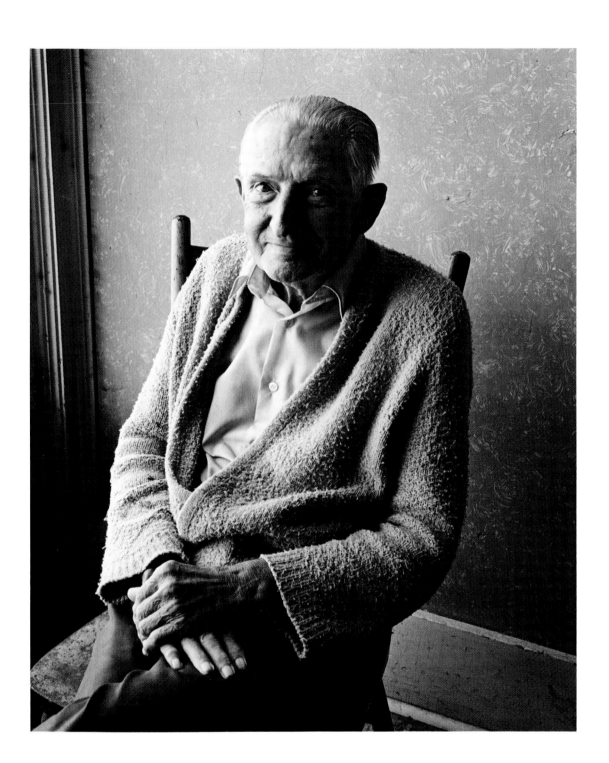

10 | Mike Adams, Don Shenant, Movie Ushers, Chillicothe

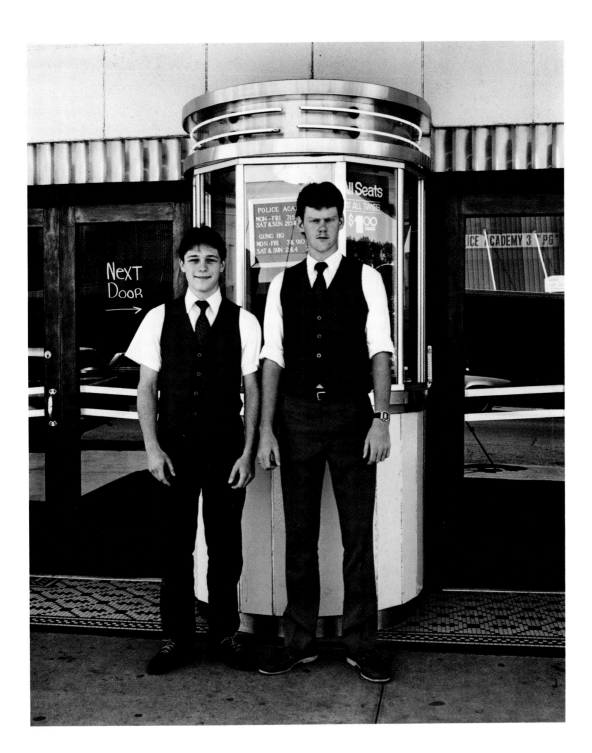

11 | Rose Dunbar, Bakery Clerk, Chillicothe

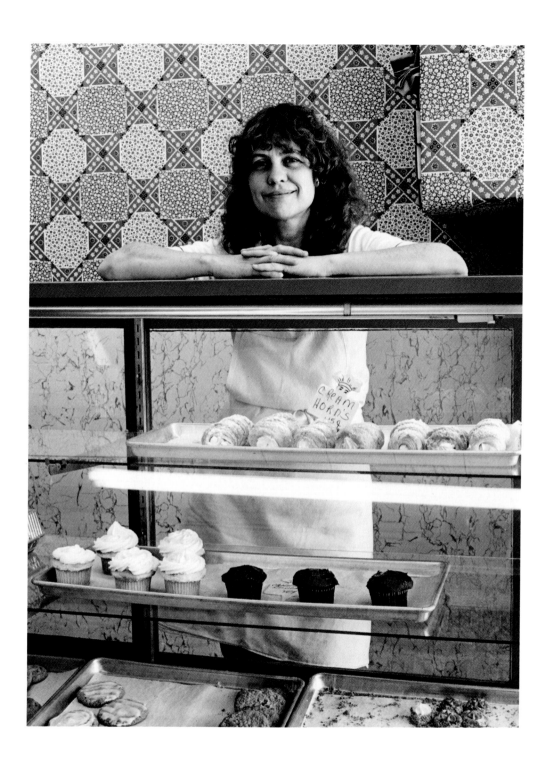

Boy on Penny Scale, Chillicothe

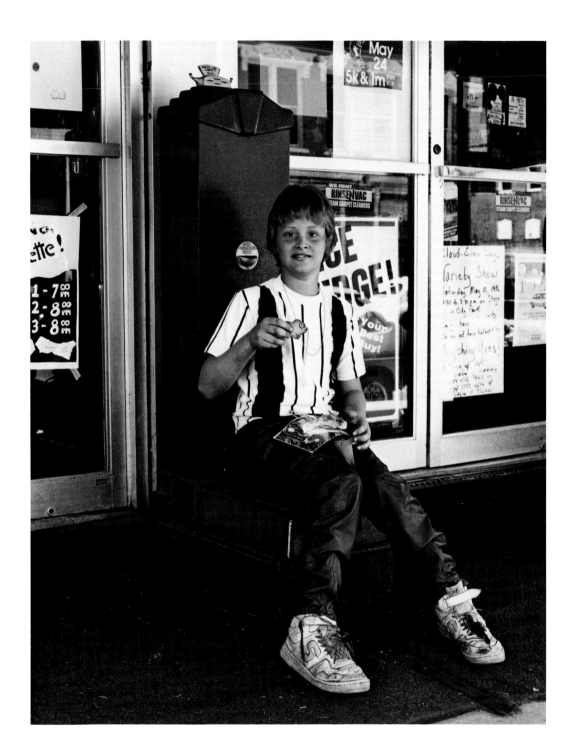

13 | Clifford Davis, Elevator Superintendent, Cisco Co-op Grain Company

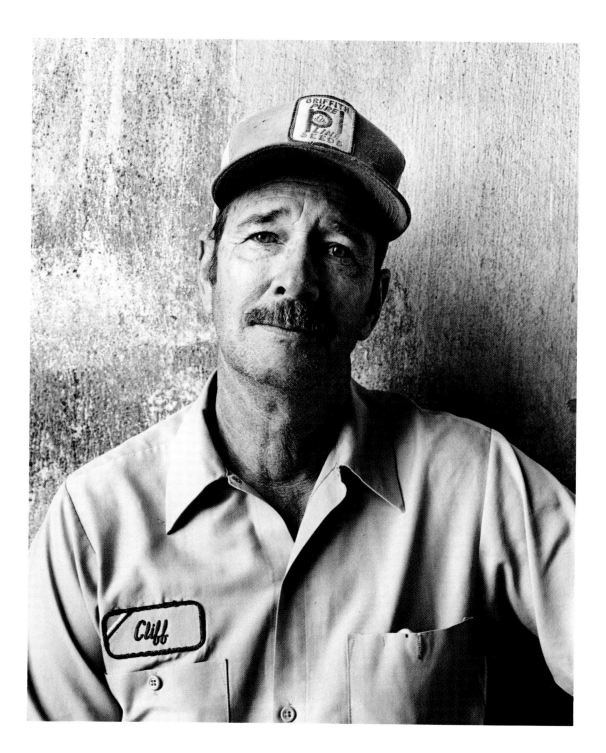

14 | B. Gregory Nolan, Jr., Petroleum Manager,
Cisco Co-op Grain Company

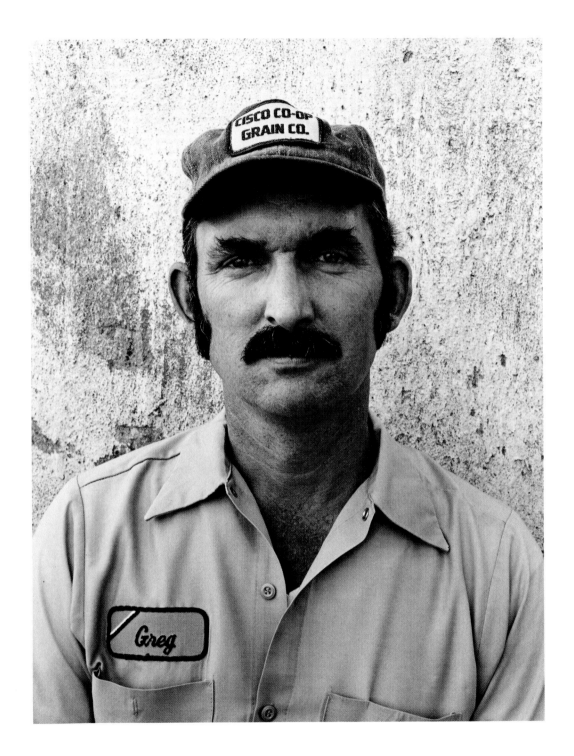

15 | Gary Hunter, Elevator Superintendent, West Elevator,
Cisco Co-op Grain Company

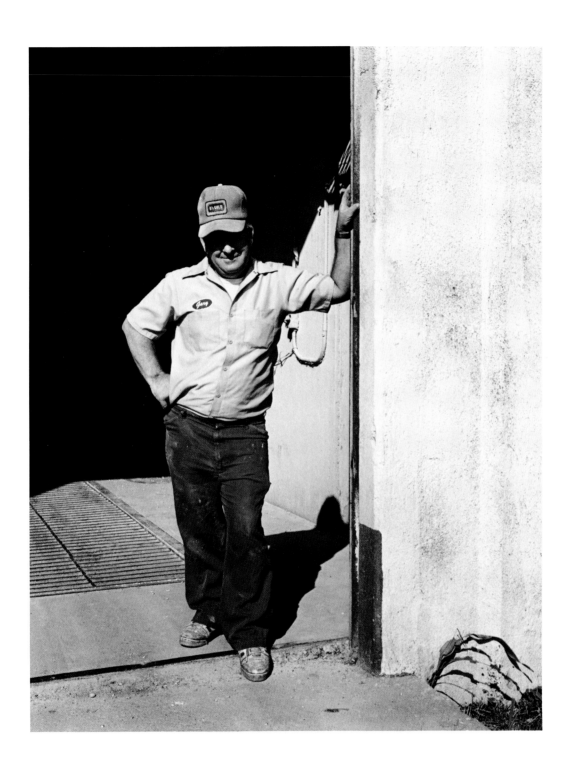

16 | John M. Carson, Grain Elevator Owner, Clarence

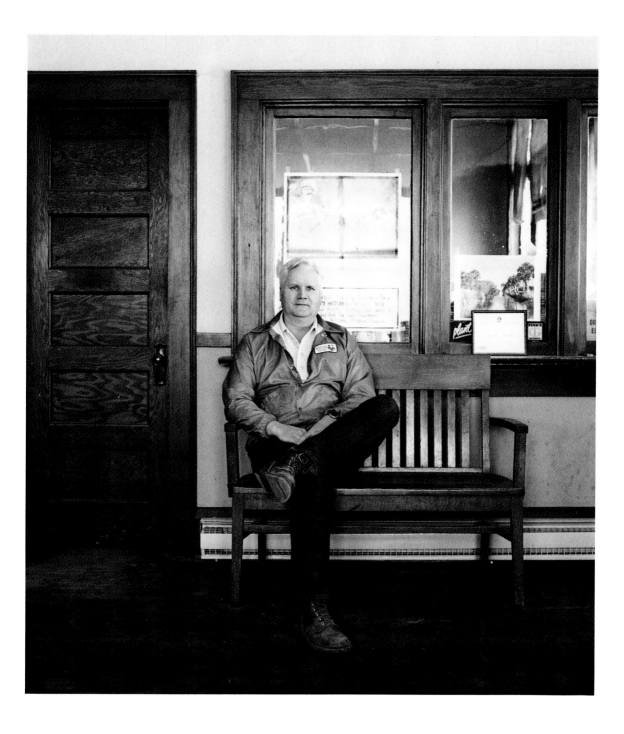

17 | Danny Kukuck, Rian Tolan, Joshua Mathis, Colfax

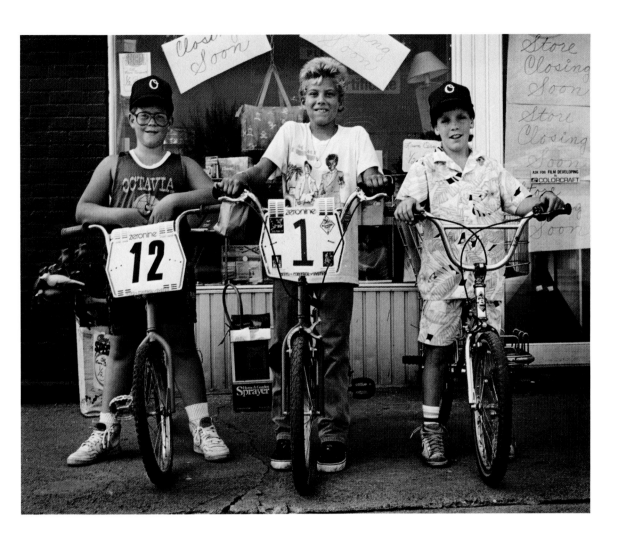

Lonnie Boswell, Terry Scott, Danvers

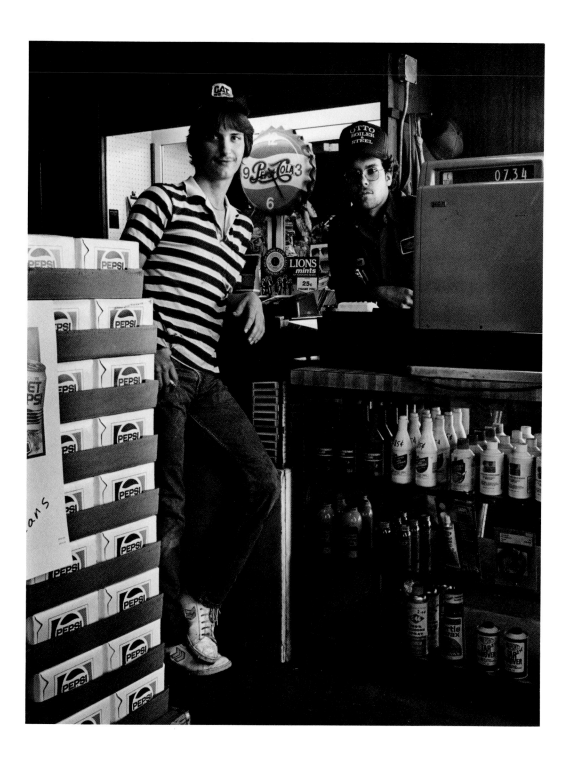

19 | John Palombo, Hardware Store Clerk, Deland

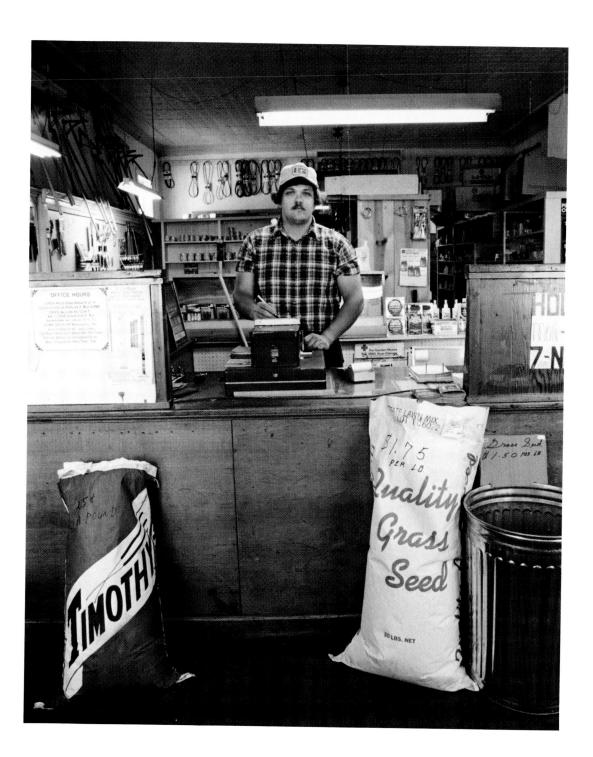

Jewell Maria, Grocery Owner, Deland

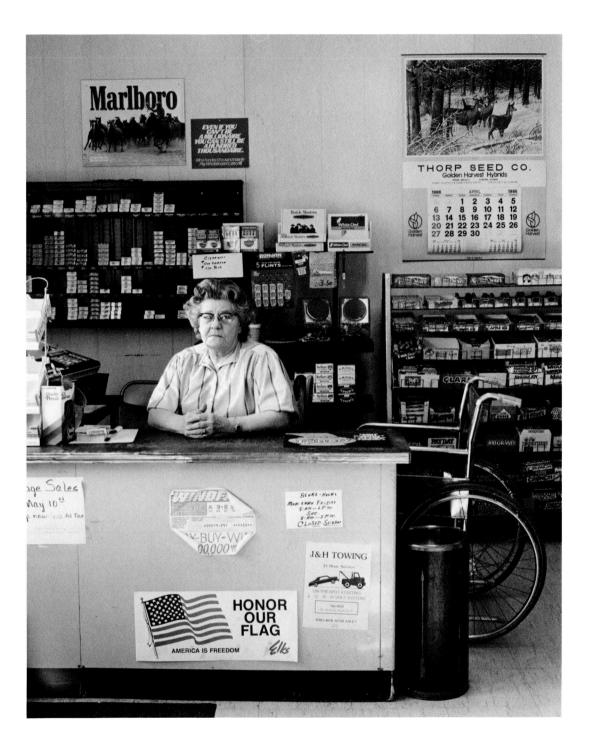

John Watson, Implement Dealer, Delavan

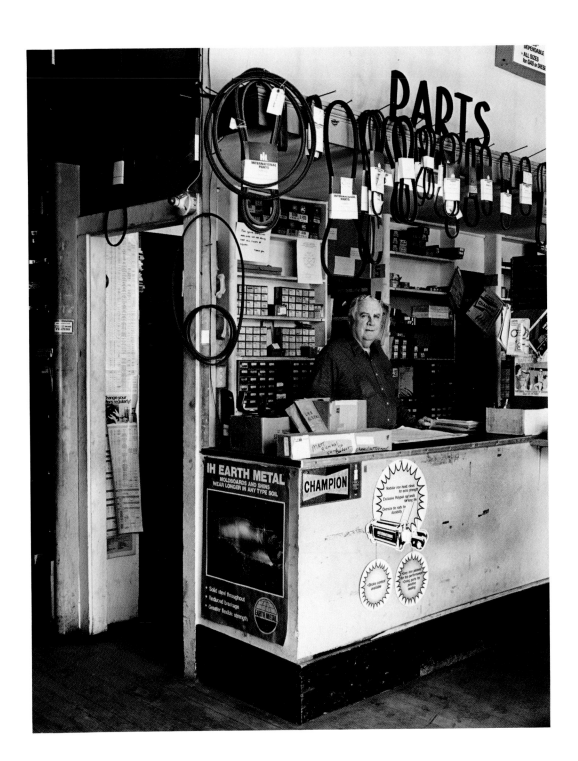

Alan Beymer, Laborer, Delavan

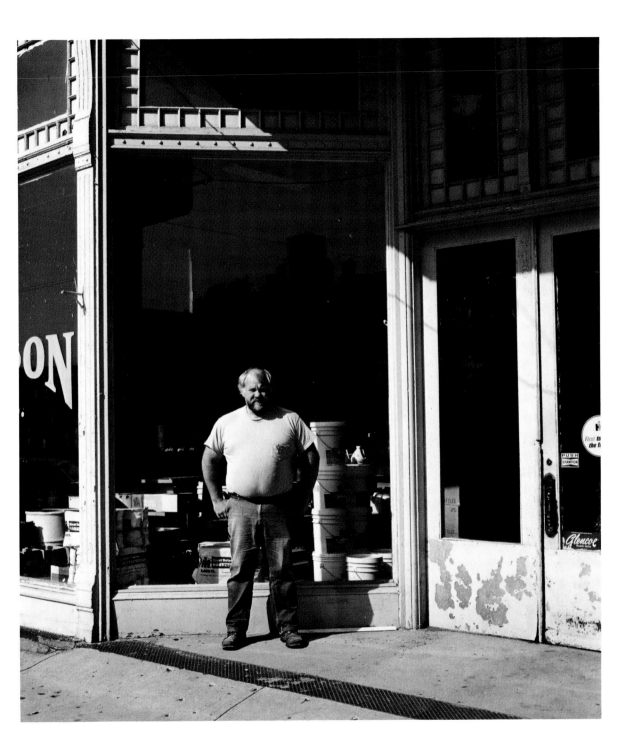

23 | Kurt H. Neumann, Elevator Employee, Dewey

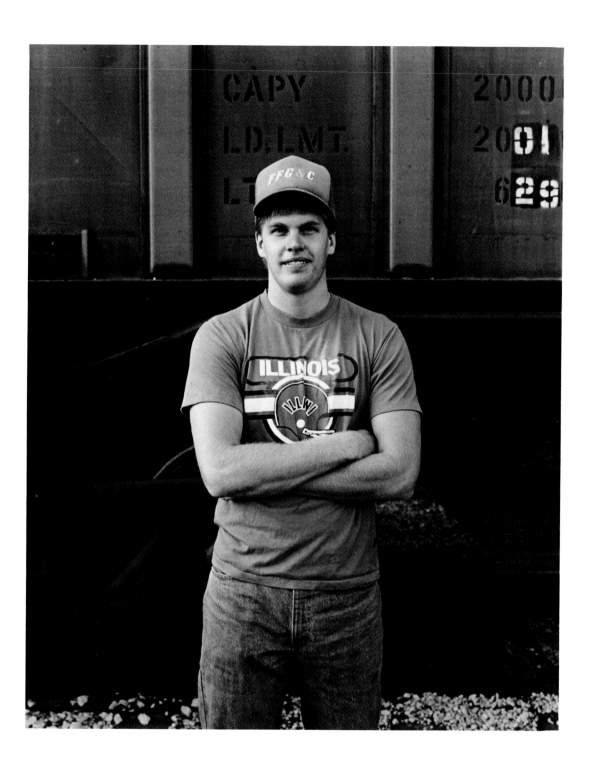

Randy Ward, John Pottorf, Easton

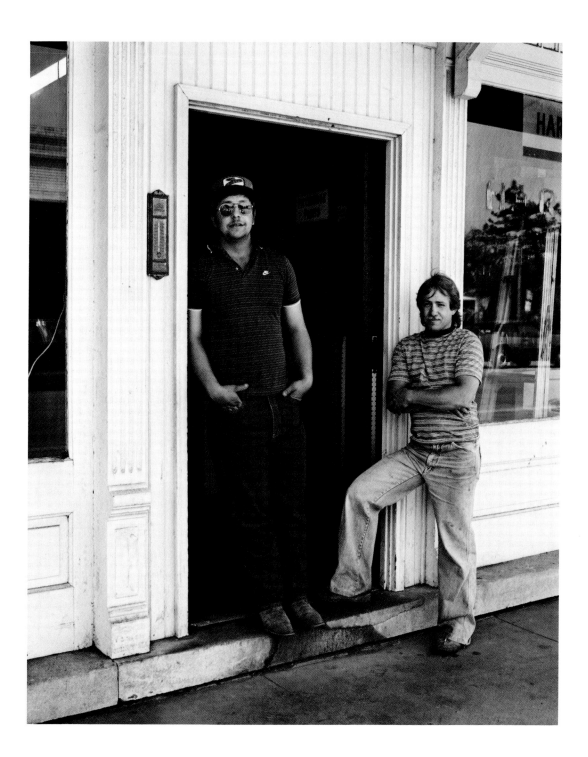

25 | John M. Hatteberg, Harold Jones, Elliott

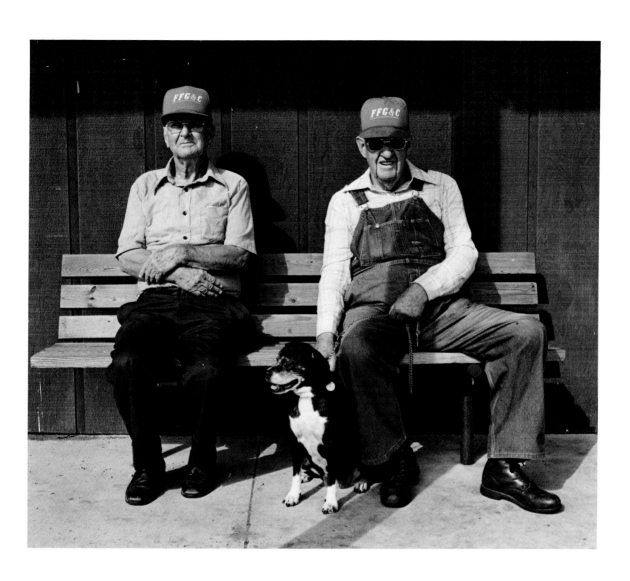

Janet Brewer, Café Owner, Elliott

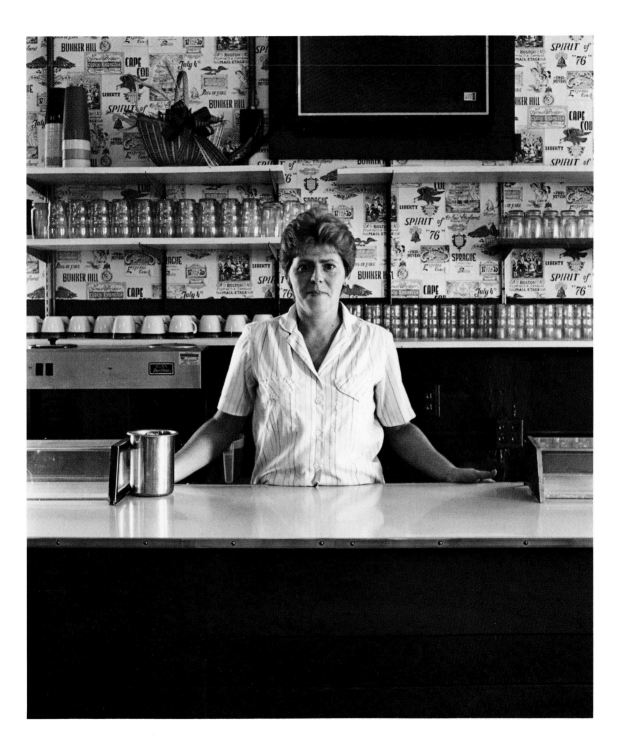

27 | Daryl Brewer, Farmer, Hog Producer, Elliott

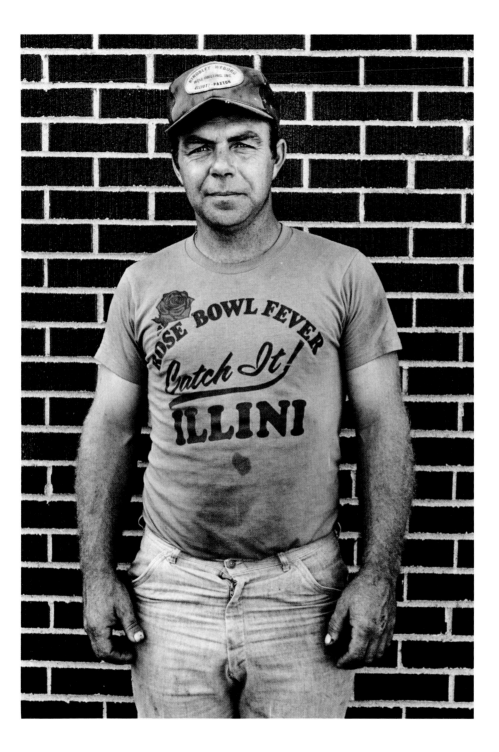

| Roscoe Harding, Retired Railroad Worker, Elliott

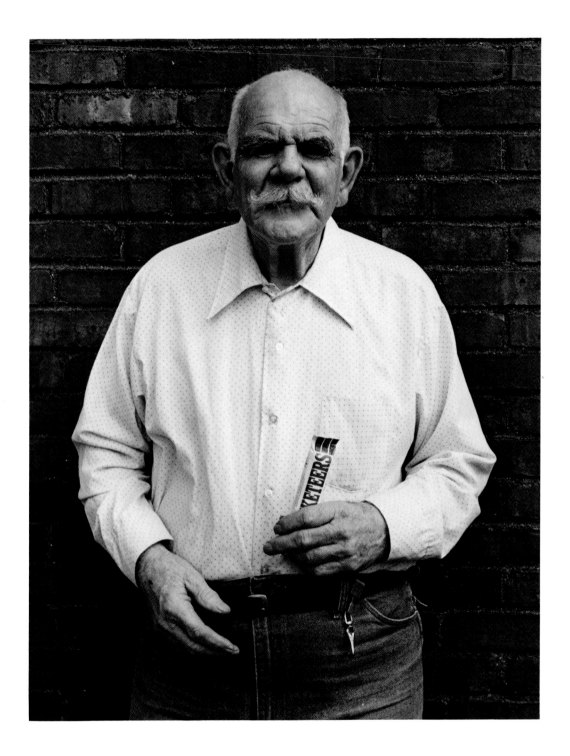

29 | Everett Billings, Gas Station Owner, Emden

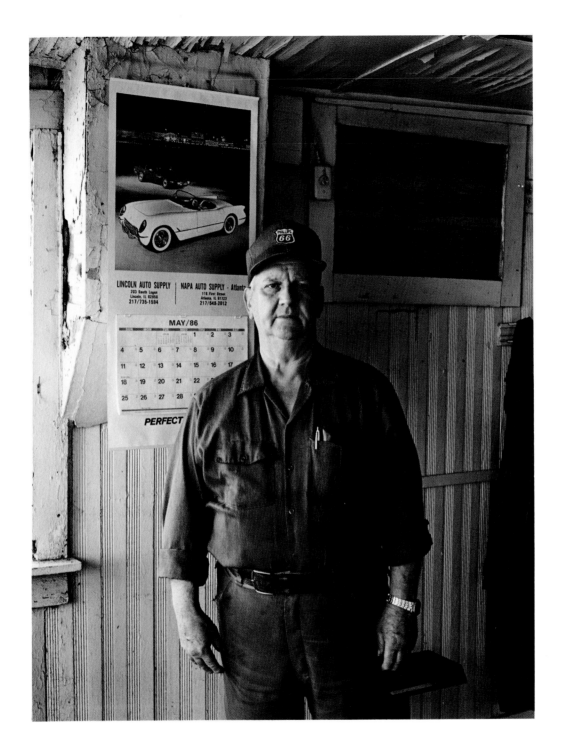

30 | Timothy Noble, John Aper, Grain Elevator Workers, Emden

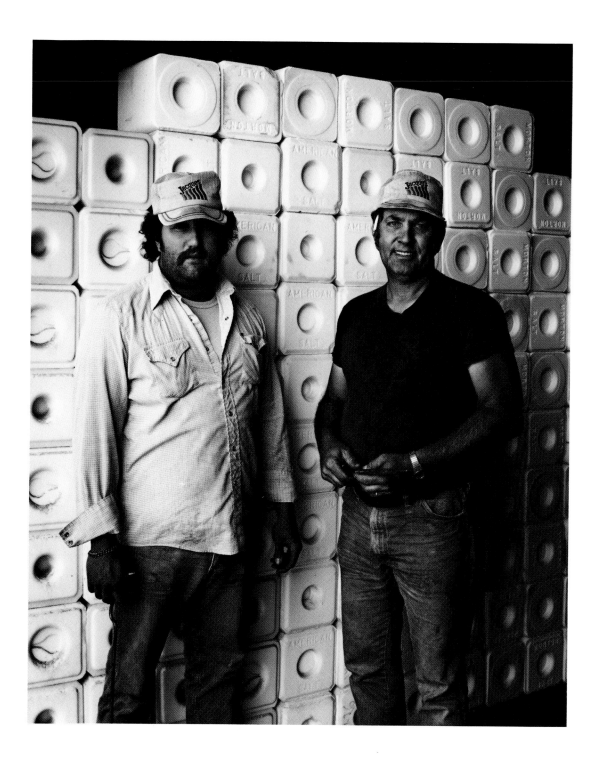

31 | Jim Douglas, Junior Duffy, Ferris

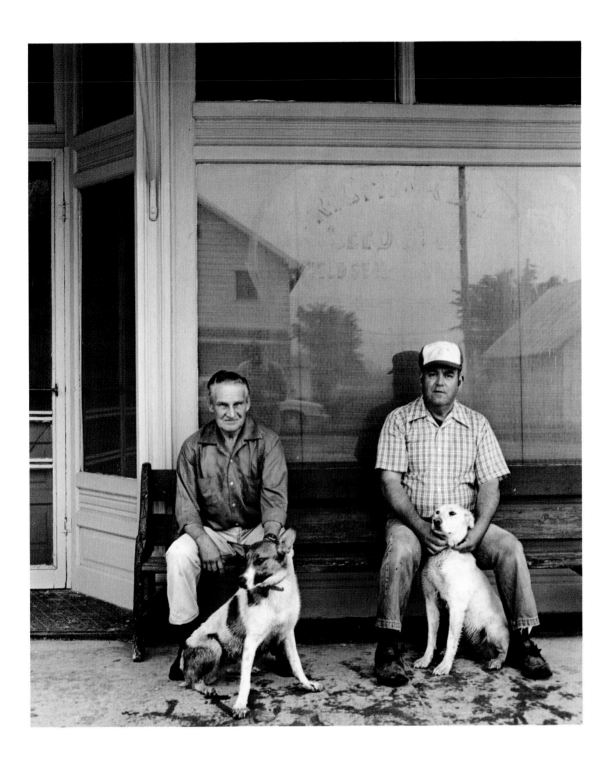

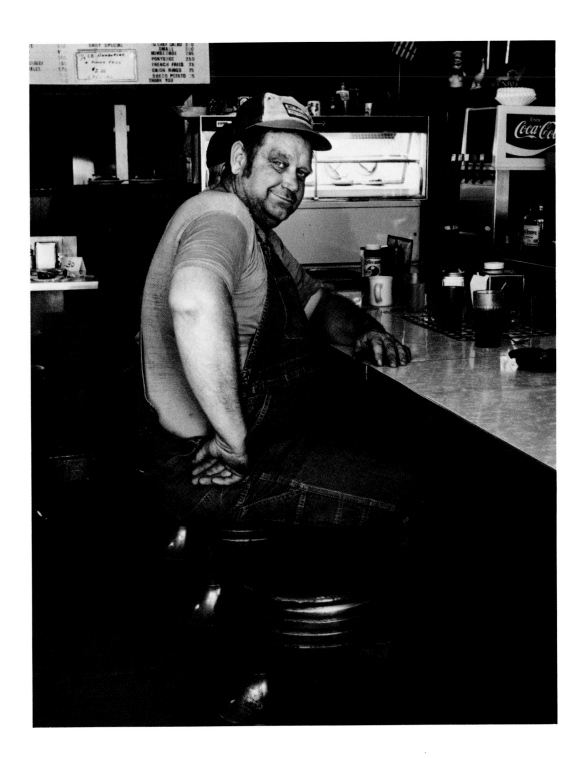

33 | Tommy Deckard, Retired Coal Miner, Greenview

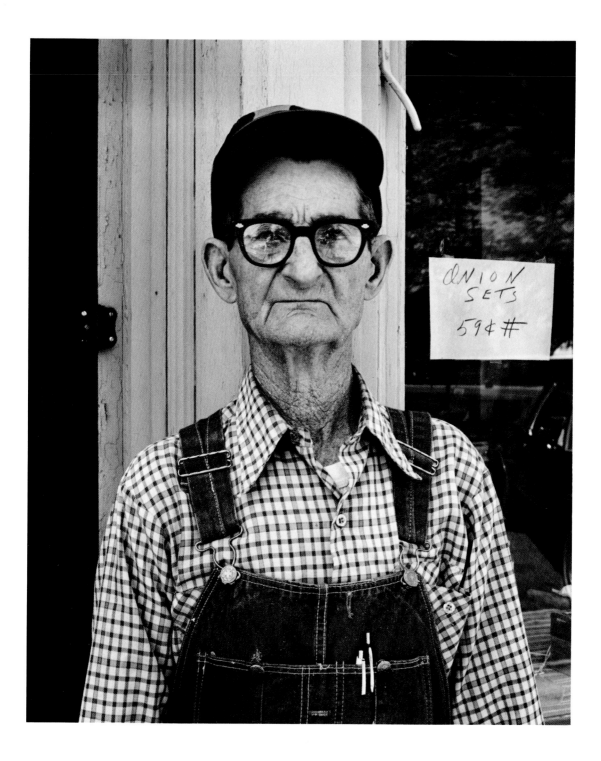

Sandi Hammer, Hugo

Matt Hammer, Hugo

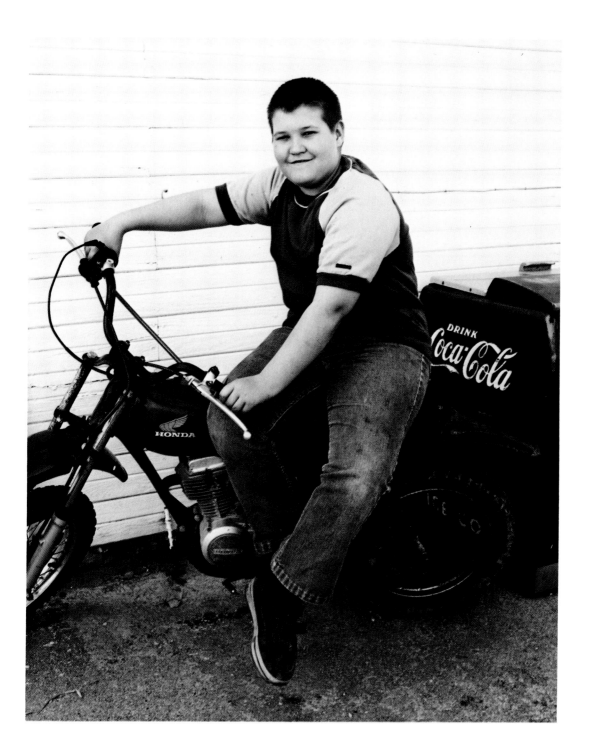

Richard W. Hines, Retired from Fertilizer Business,
Candymaker, Humboldt

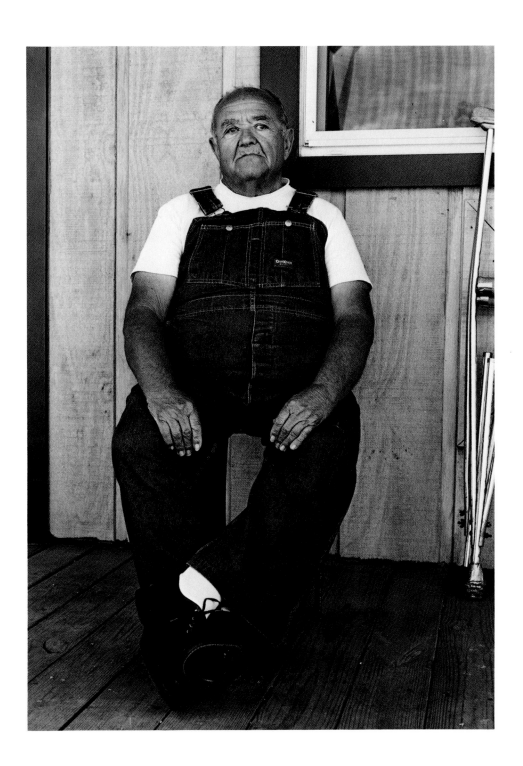

37 | Steve Mitchell, Service Station Manager, Ivesdale

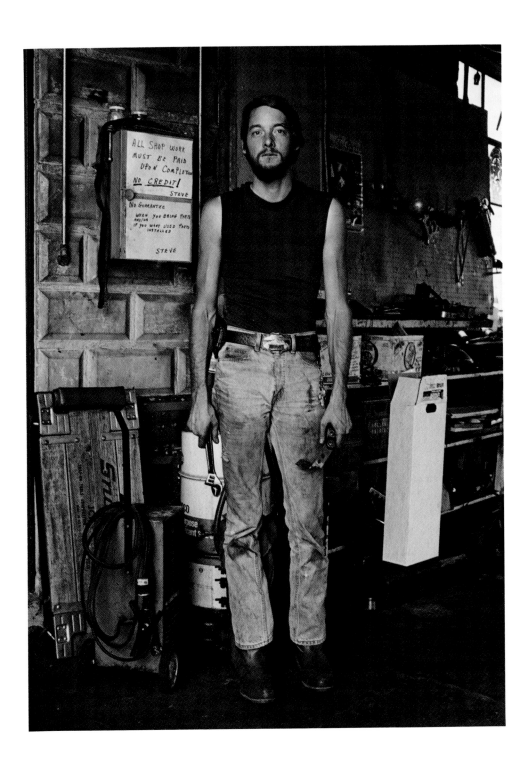

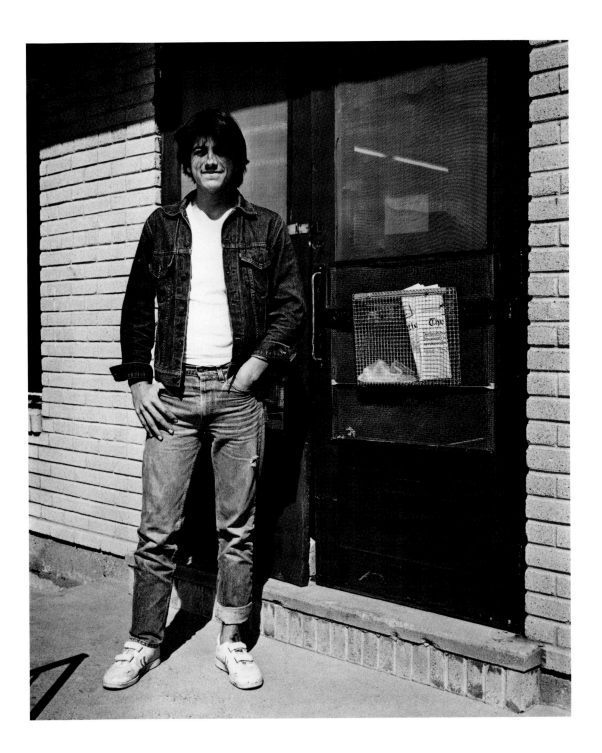

Boyd Landgrebe, Retired Farmer, Lovington

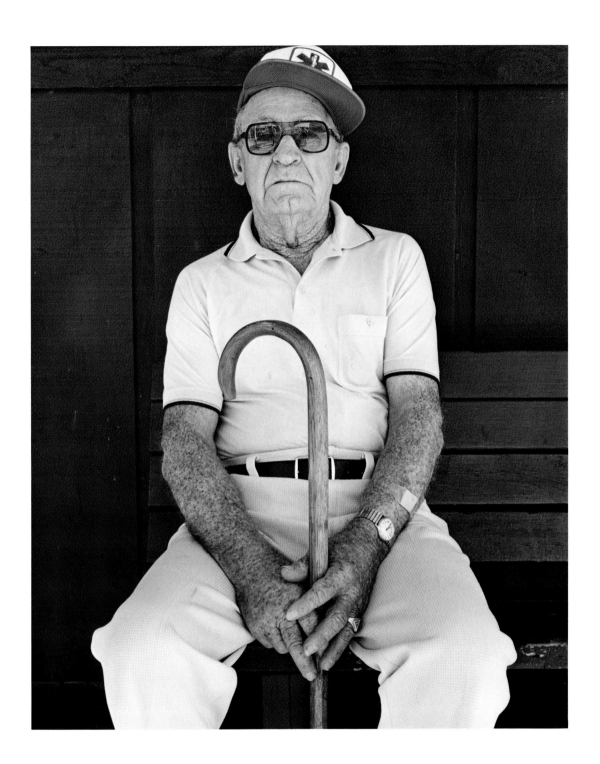

40 | R. W. Cheevess, Retired Railroad Worker, Lovington

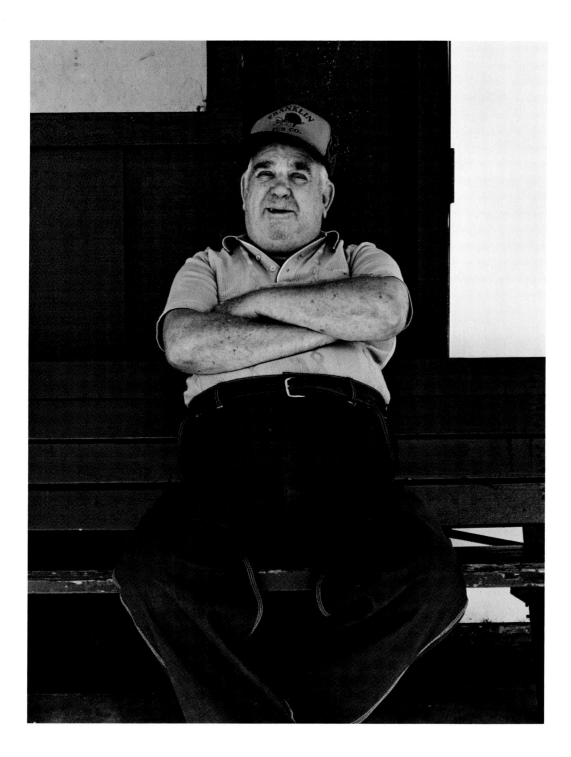

41 | Rex Phillips, Grain Elevator Worker, Ludlow

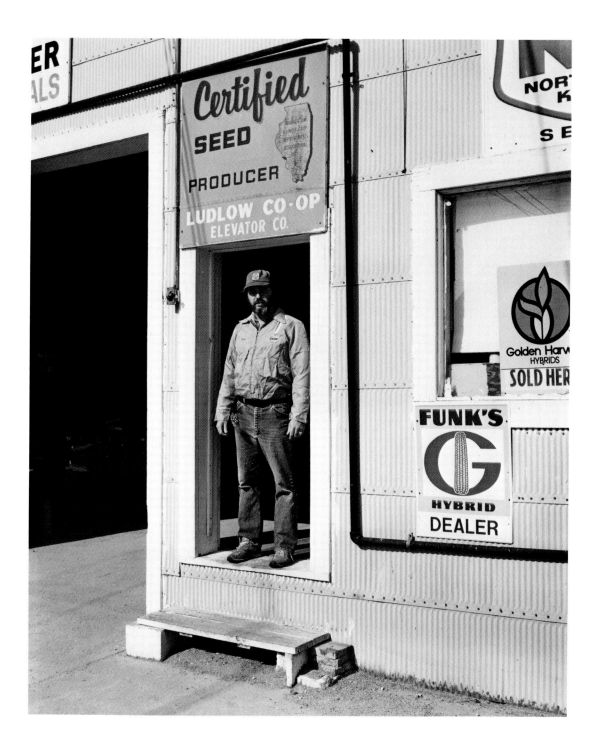

Gus Laidig, Ellsworth Fluegel, Jim Shonk, Mackinaw

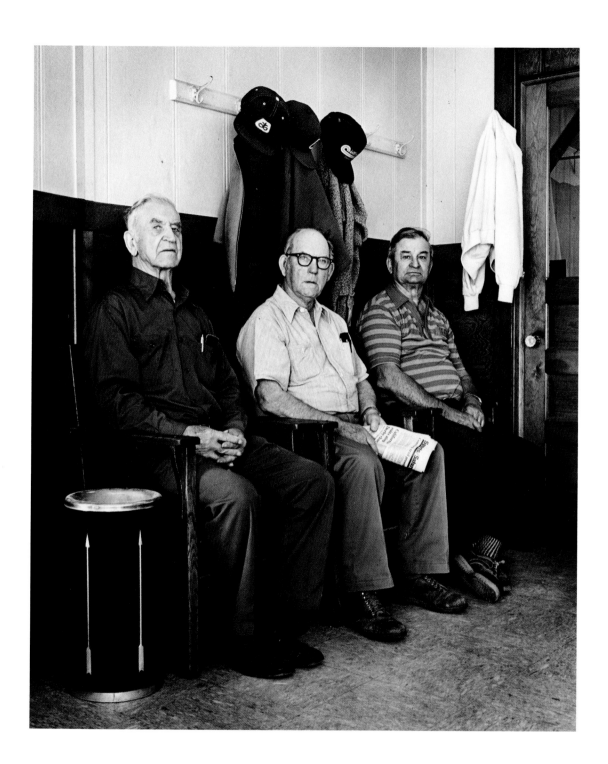

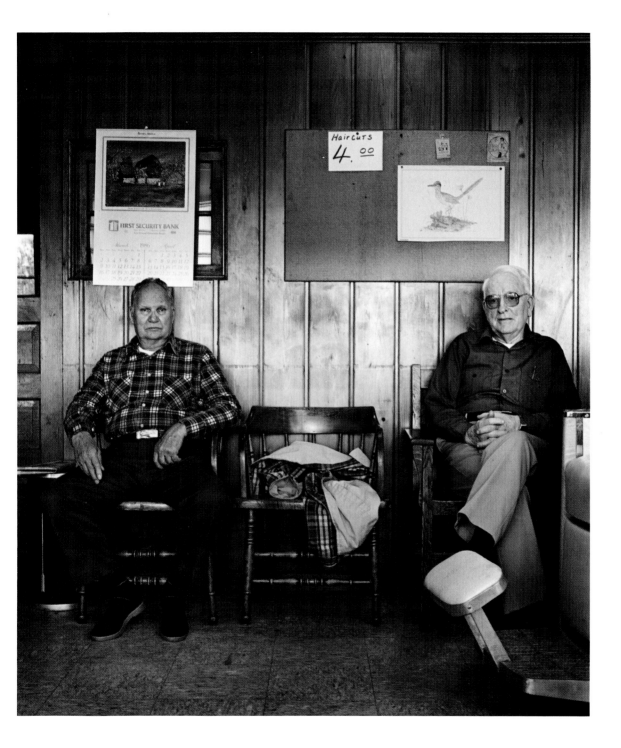

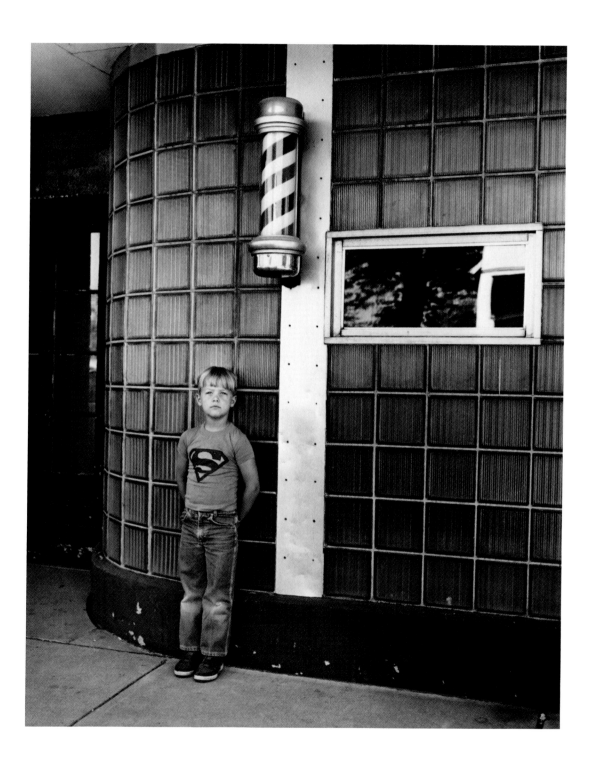

45 | Jean Hubner, Waitress, Evergreen Café, Melvin

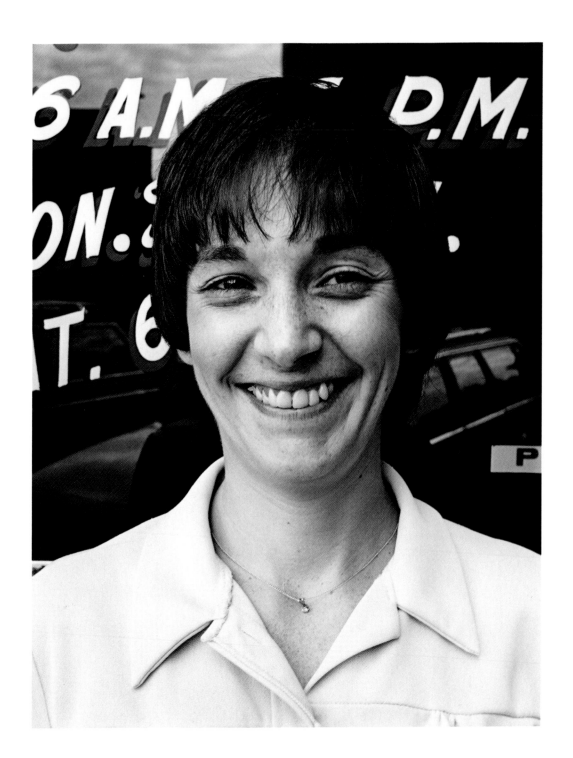

46 | Mark Punjwani, Grocery Clerk, Mike Dhanani, Manager,
Melvin Super Market

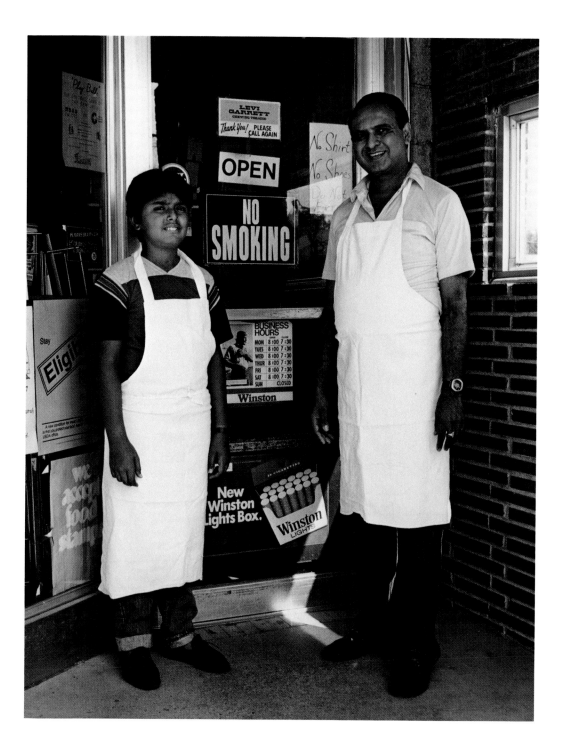

47 | Kena Clark, Lori Allison, Waitresses, Milford

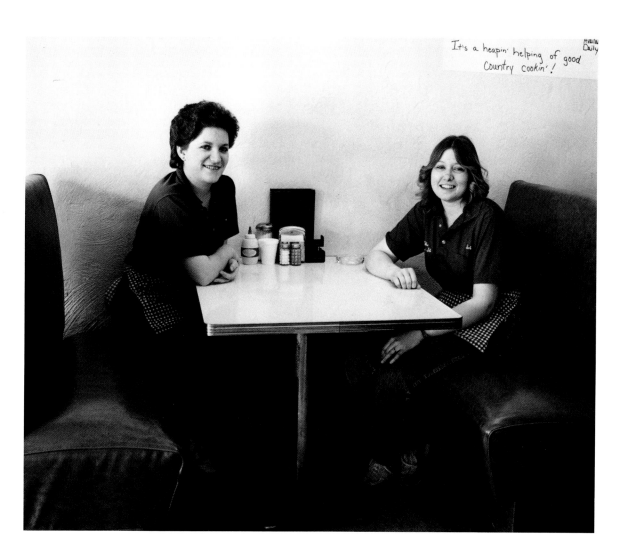

It's a heapin' helping of good
Country cookin'!

Porter K. Bertram, Gas Station Owner, Milford

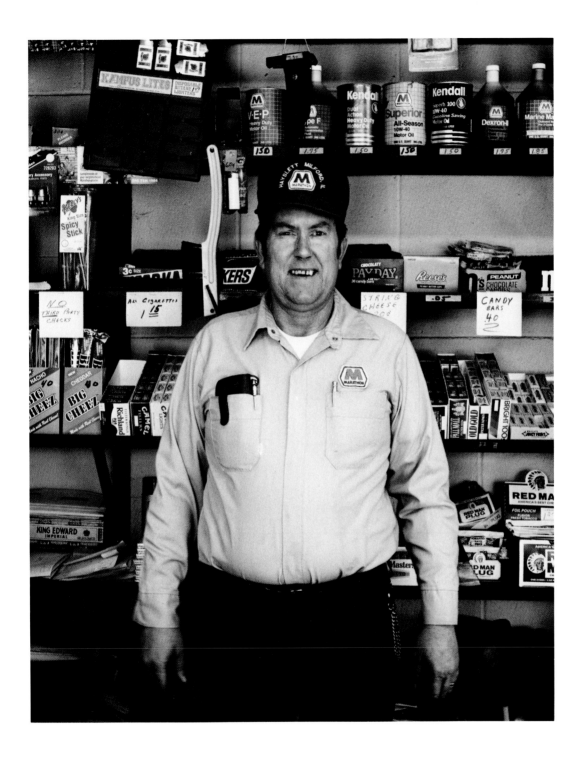

49 | David Watts, Truck Driver, Milford

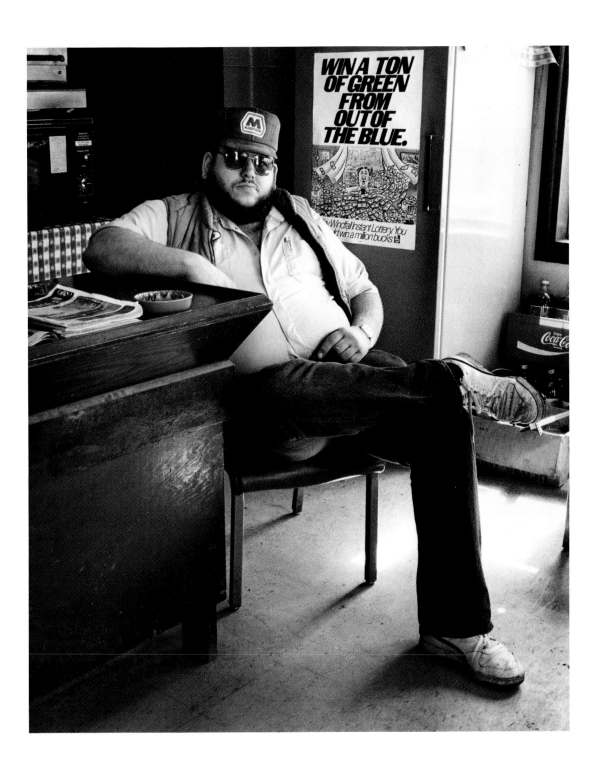

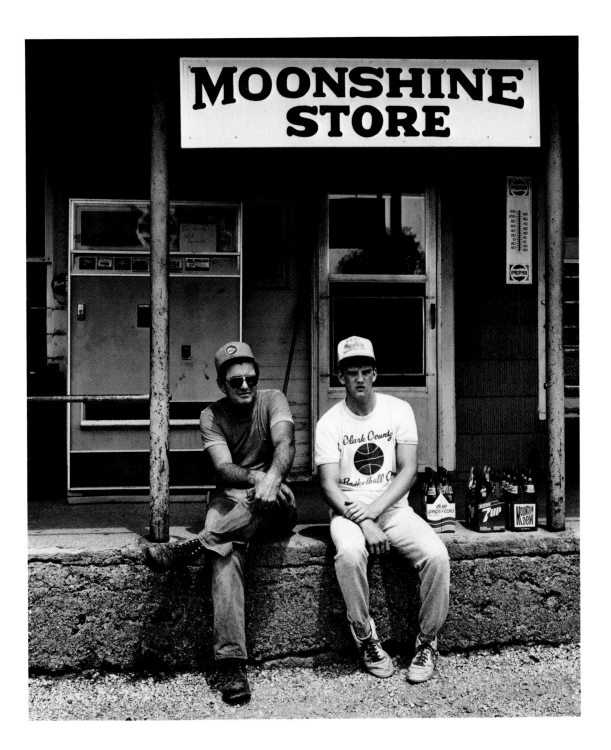

51 | Roy Tuttle, Grocery/Café Manager, Moonshine

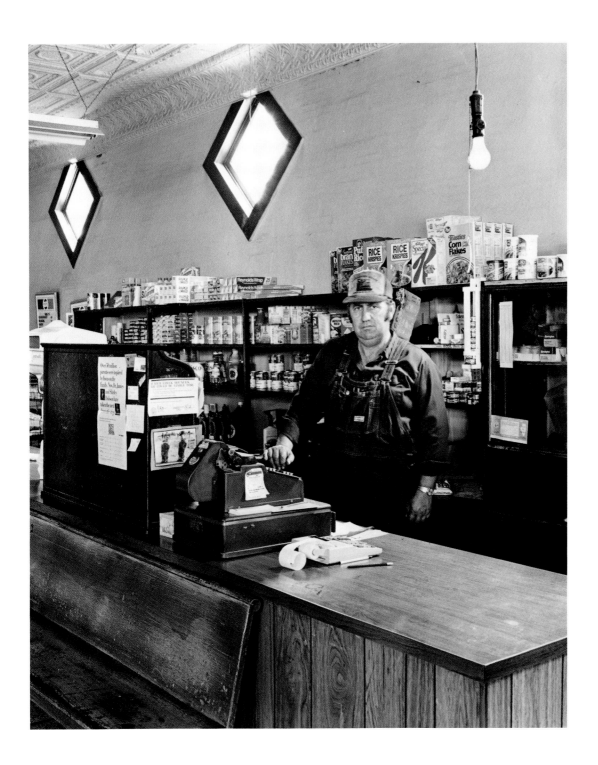

52 | Clyde Purcell, Gerald Misner, John Mark Haley, Moonshine

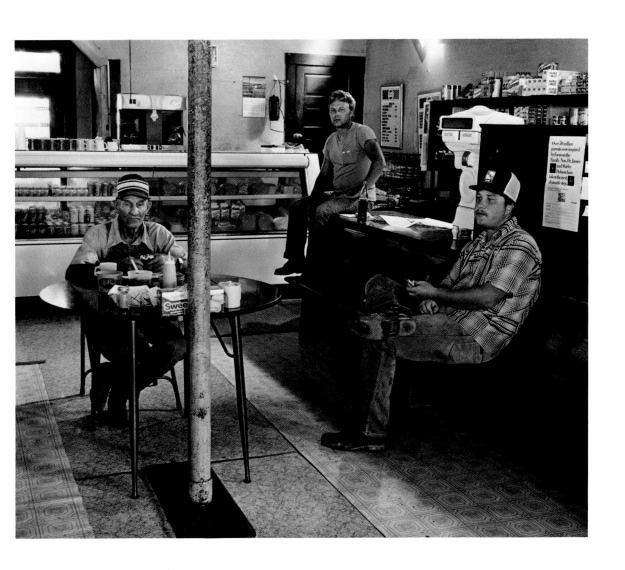

53 | Zane Shelton, Garage Owner, New Holland

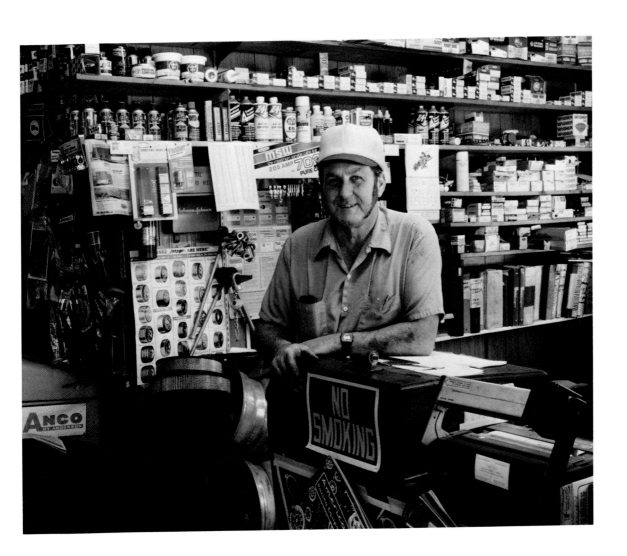

Don Brant, Mechanic, New Holland

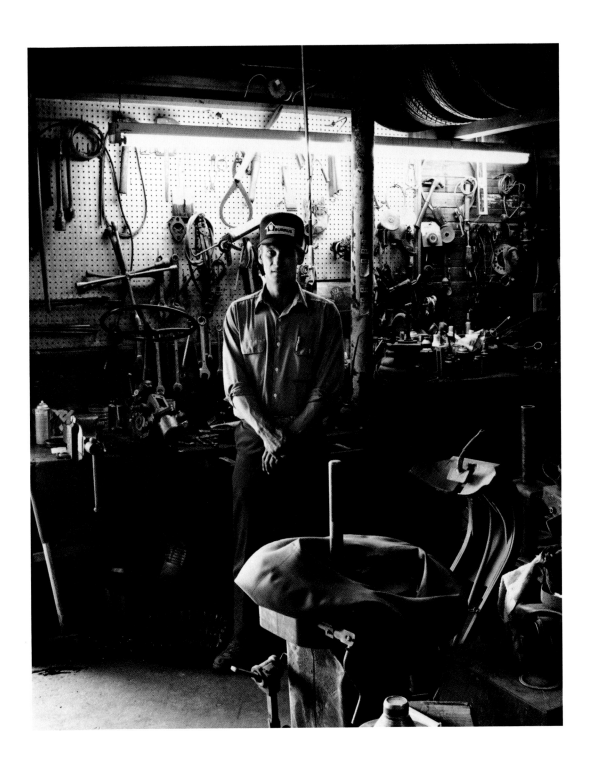

55 | Gladys Shelton, Café Manager, New Holland

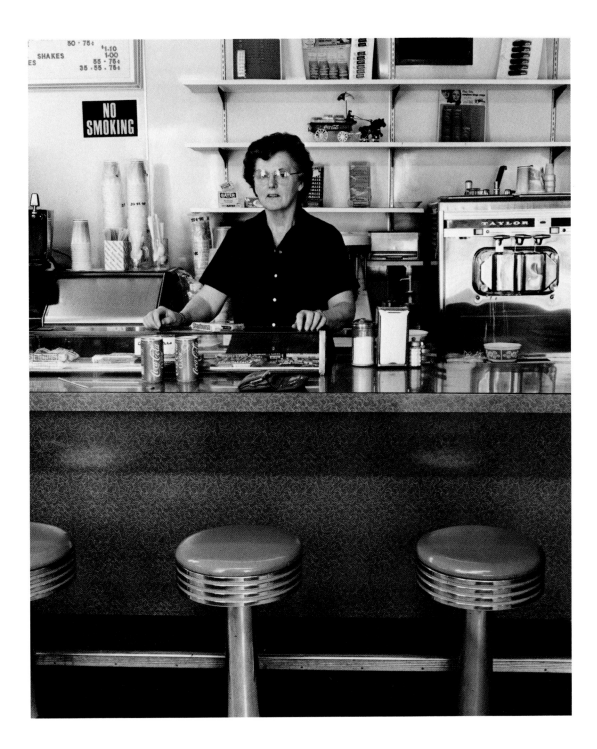

56 | Charles Bracey, New Holland

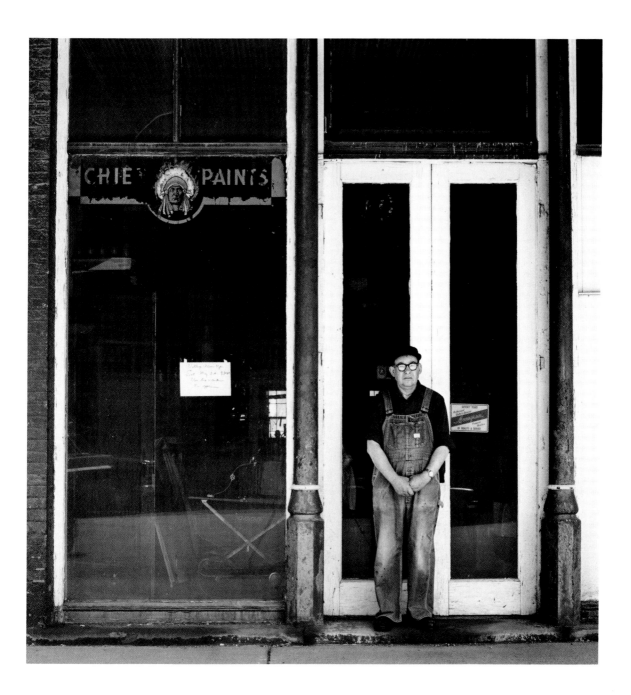

57 | Jimmy Coers, Feed Store Worker, New Holland

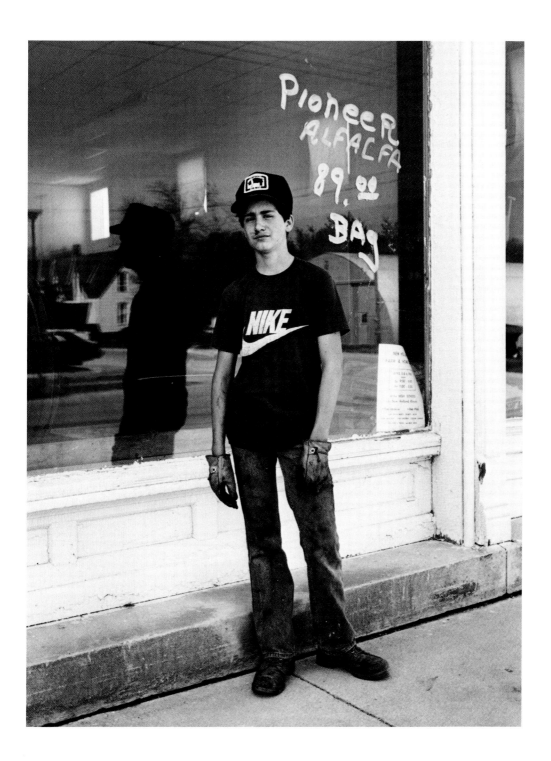

58 | Jim Johnson, Barber, Sam G. Brun, Jim's Barber Shop, Ogden

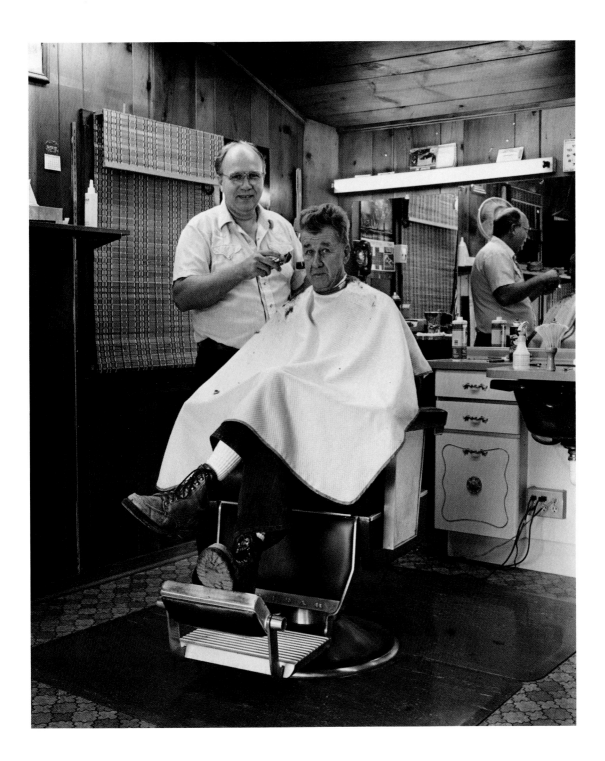

Mary Ennis, Grocery Owner, Oilfield

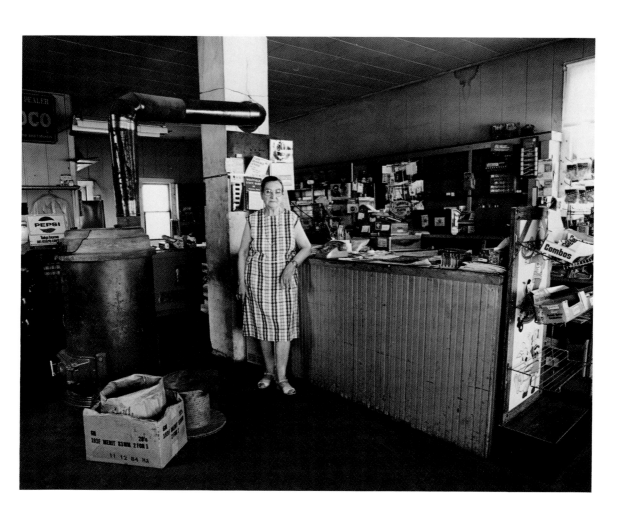

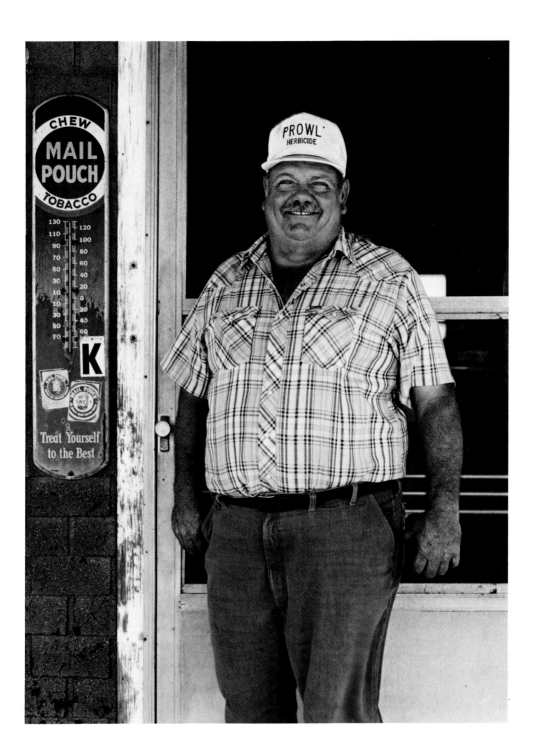

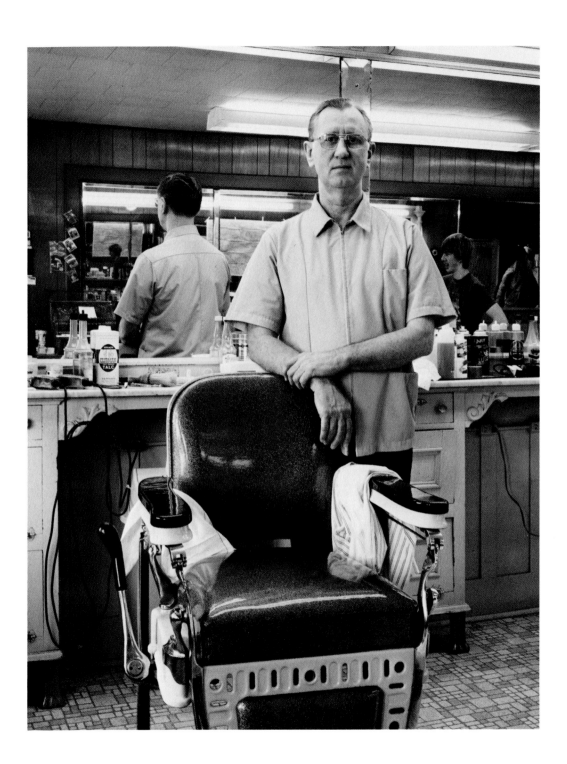

62 | William R. Orndorff, William R. Orndorff, Jr.,
Grand Prairie Grain Elevator, Philo

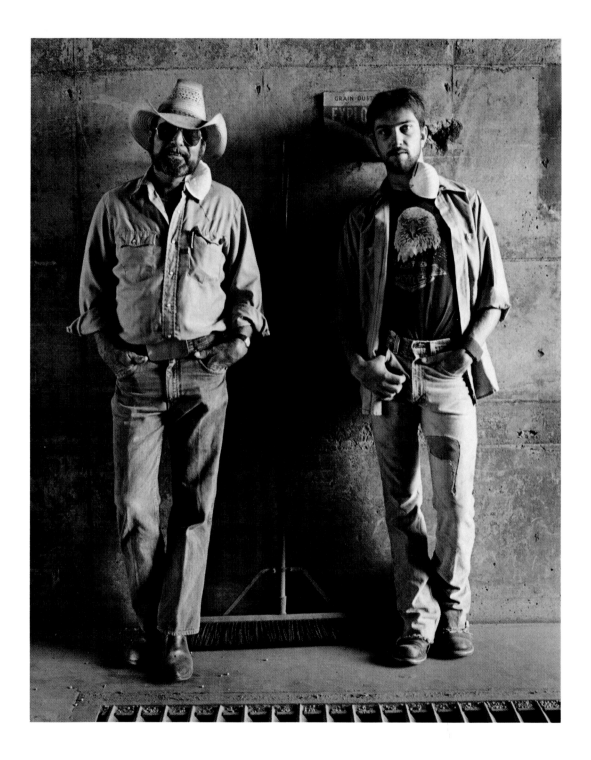

63 | William R. Orndorff, Jr., Grand Prairie Grain Elevator, Philo

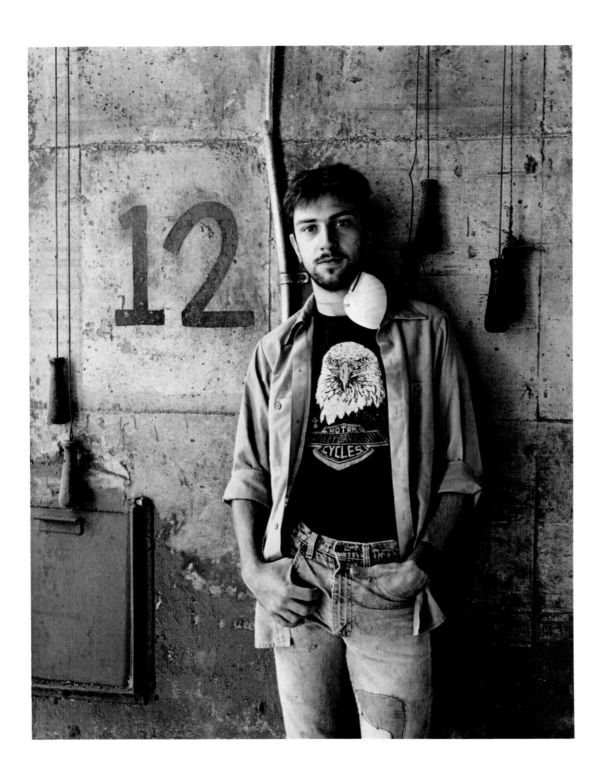

64 | Louise Fruhling, Waitress, Kathie Britt, Owner, K. J.'s
Country Kitchen, Potomac

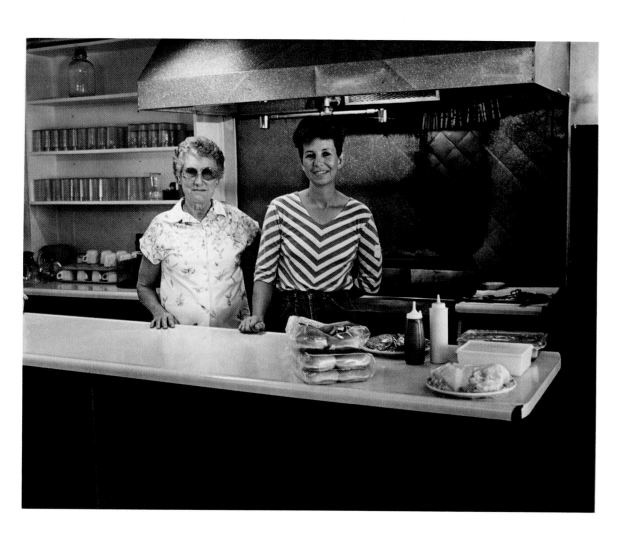

65 | Harold Hoskins, Contractor and Owner of Hoskins Café, Potomac

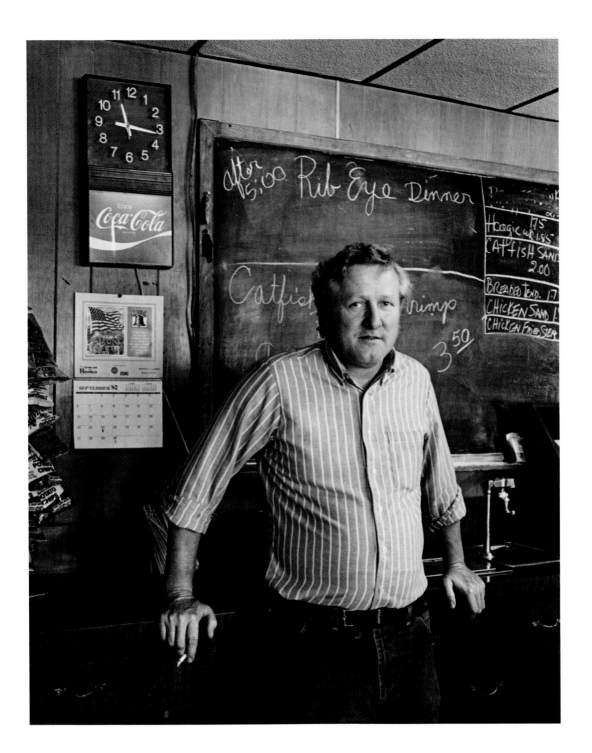

66 | Paula and Jeff Misner, Garage Owners, Rankin

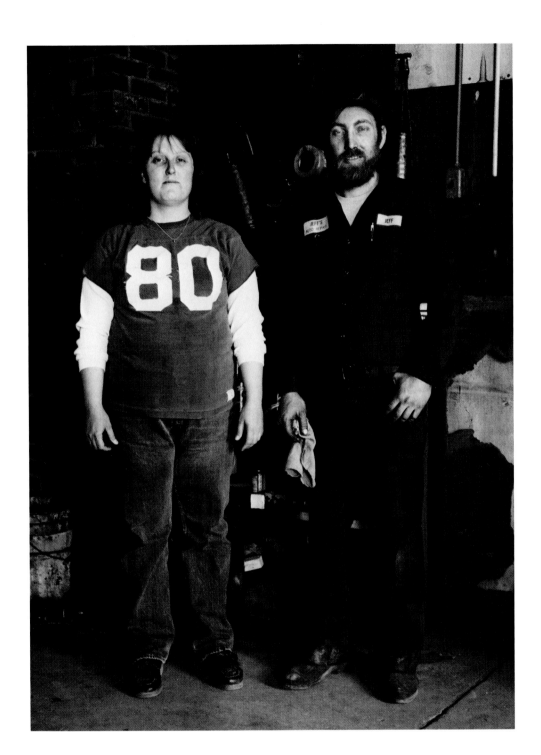

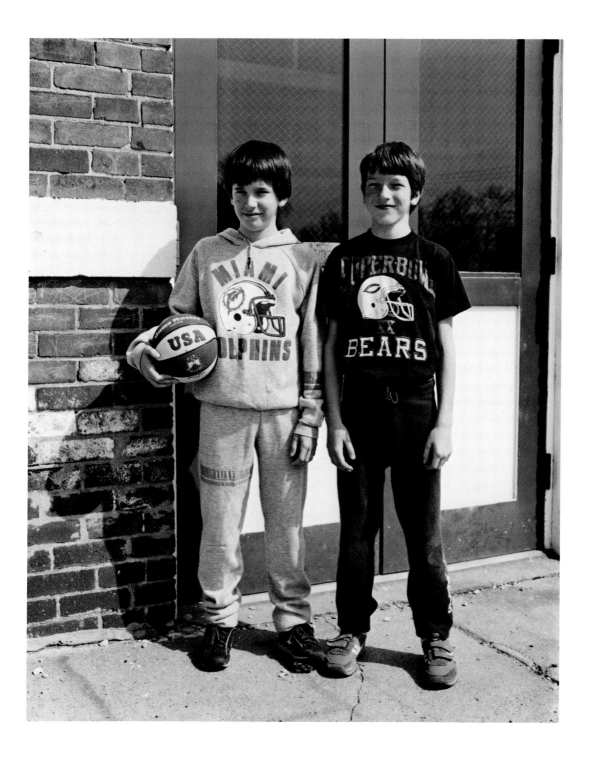

Sam Abed, Grocery Owner, Rankin

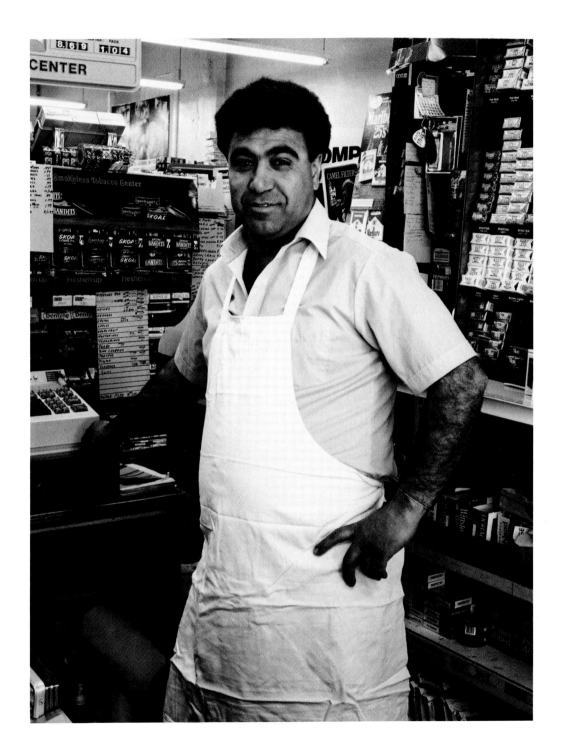

69 | Mrs. F. E. Lester, Café Owner, Redmon

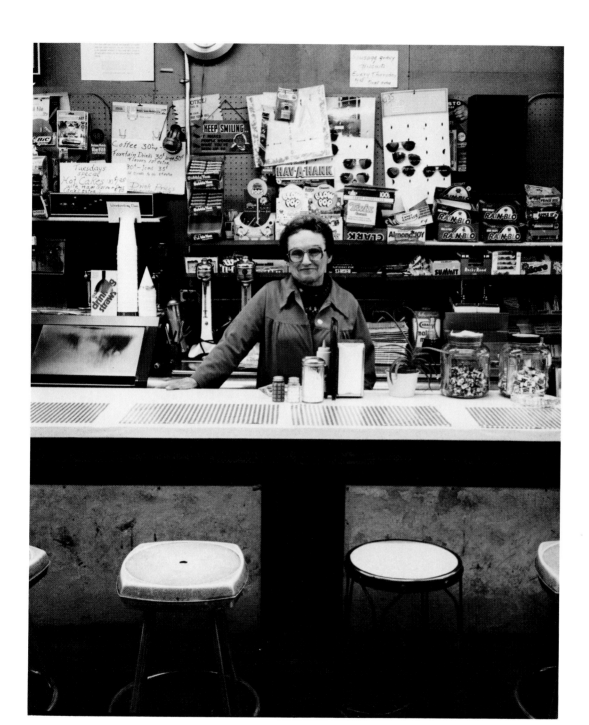

70 | Dennis Aden, Farmer, Meier-Duitsman Oil Company, Royal

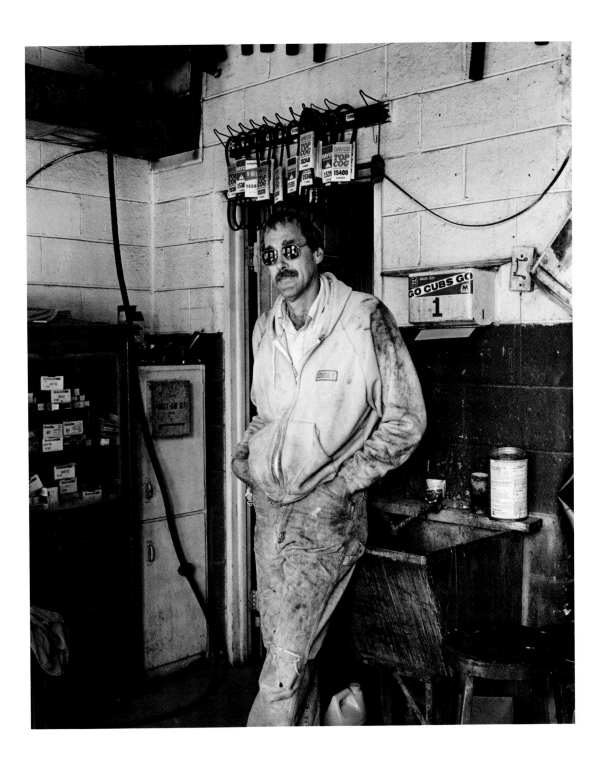

71 | Bill Reitmeier, Assistant Manager, Meier-Duitsman
Oil Company, Royal

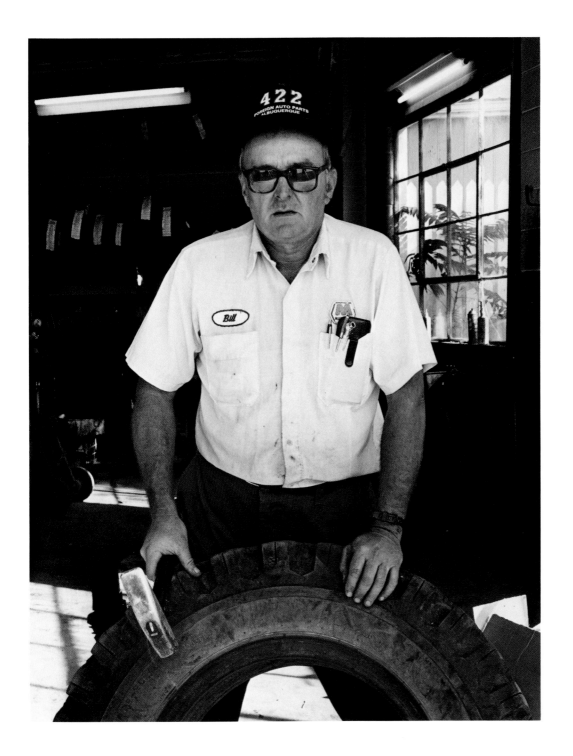

Mitch and Julie Wissmiller, Saybrook

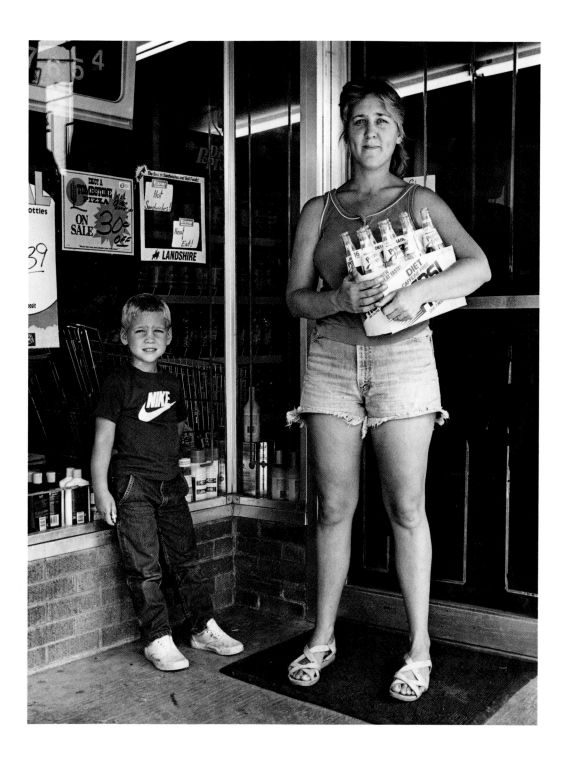

Mary Nickrent, Saybrook

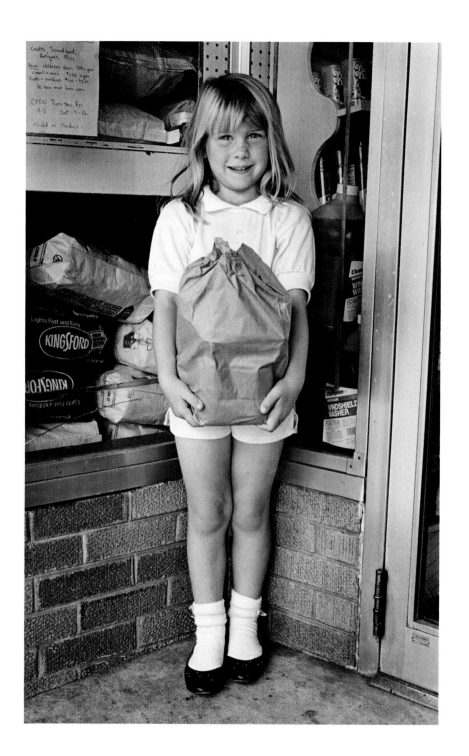

74 | Danielle Rae Stewart, Four Seasons Café, Saybrook

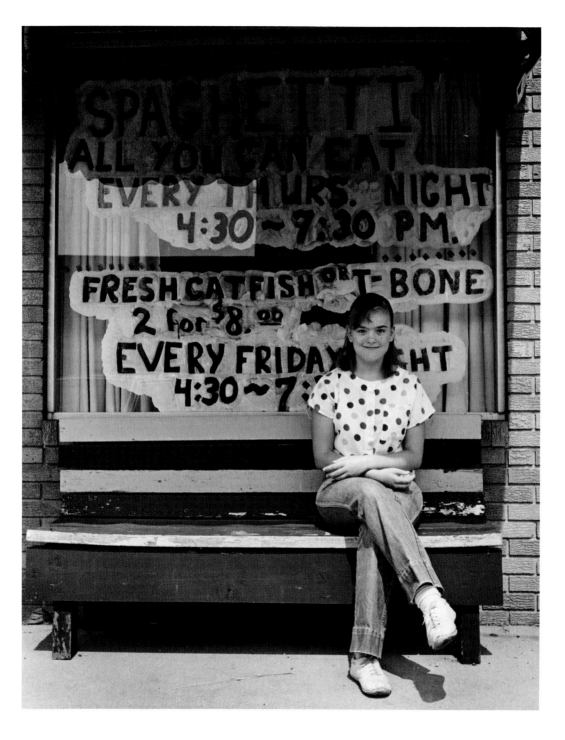

Ben Parker, Toulon

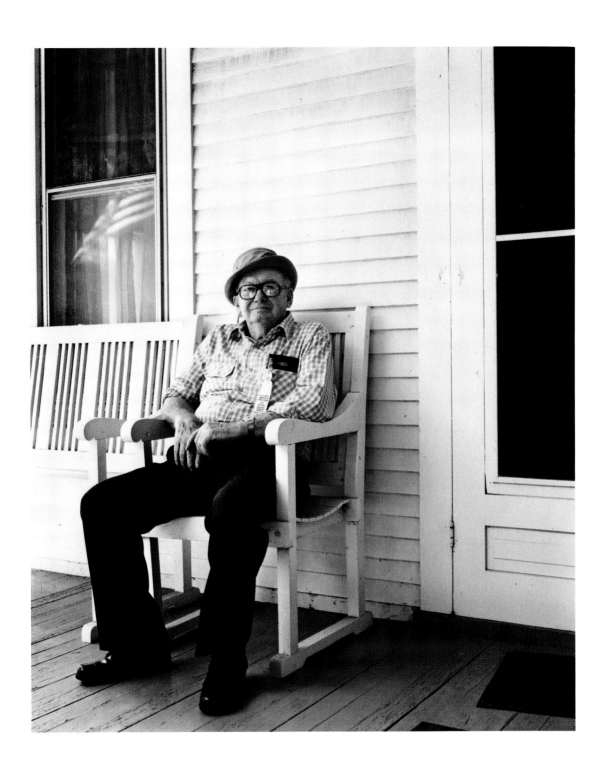

76 | Mary Cooper, Waitress, Tremont

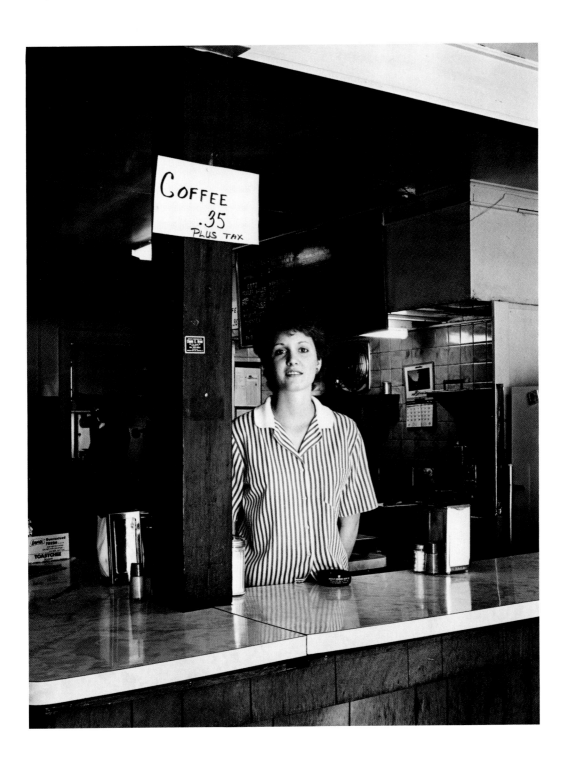

77 | David N. McGhee, Dave's Conoco, Villa Grove

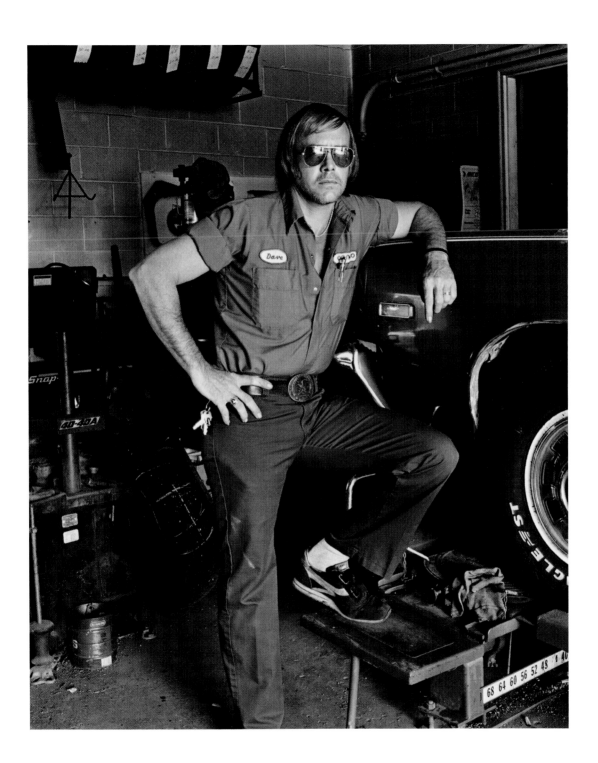

Sandy Kirkman, Dave's Conoco, Villa Grove

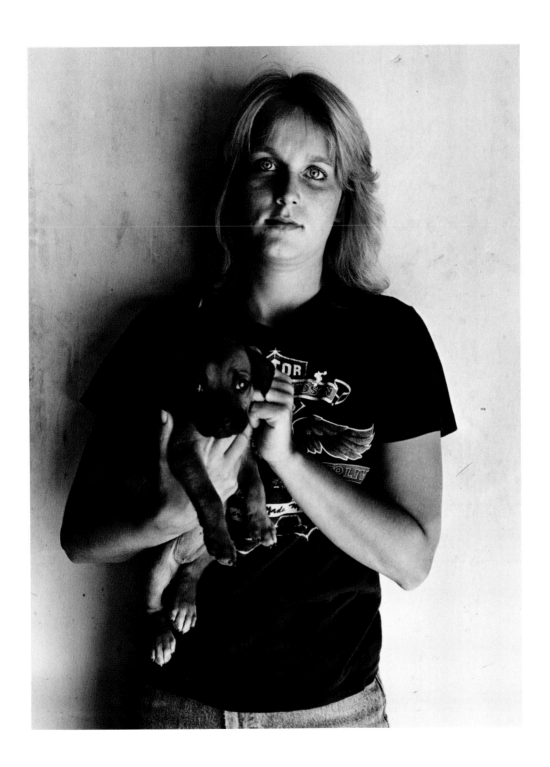

79 | Dorothy Weaver, Café Owner, Villa Grove

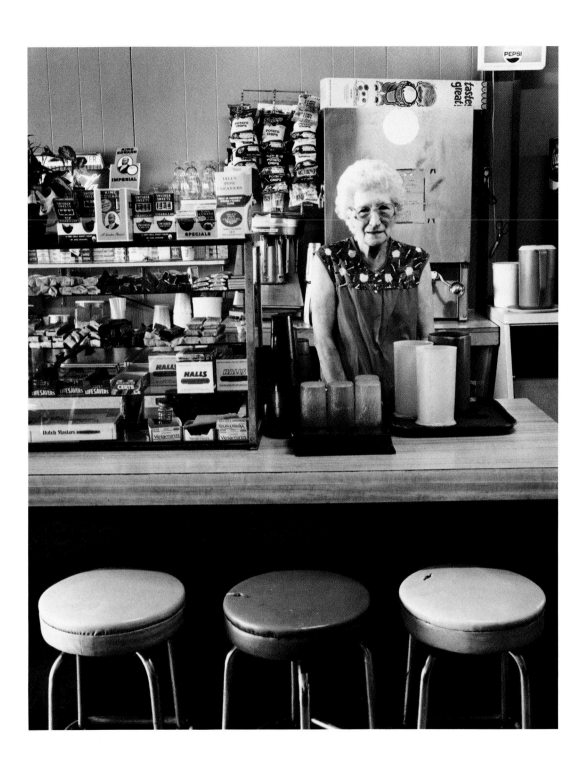

Alberta Southard, Waitress, Villa Grove

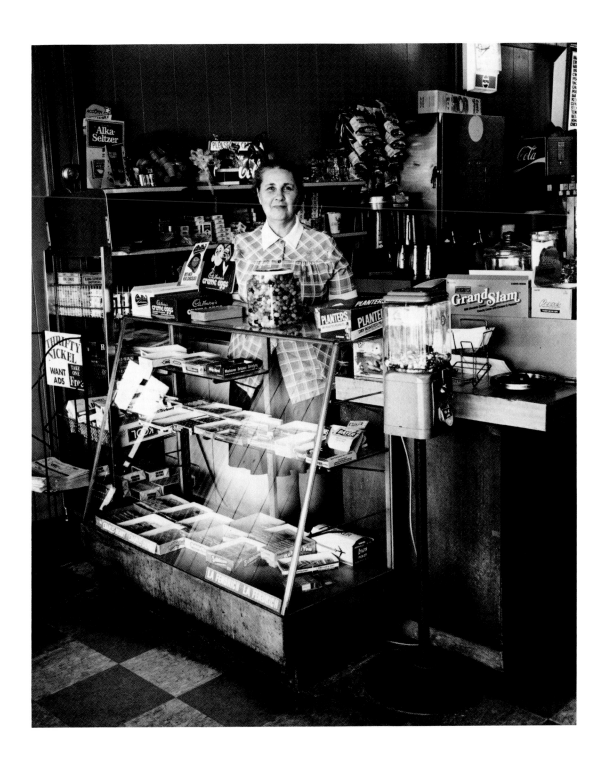

81 | Andy Smith, Waynesville

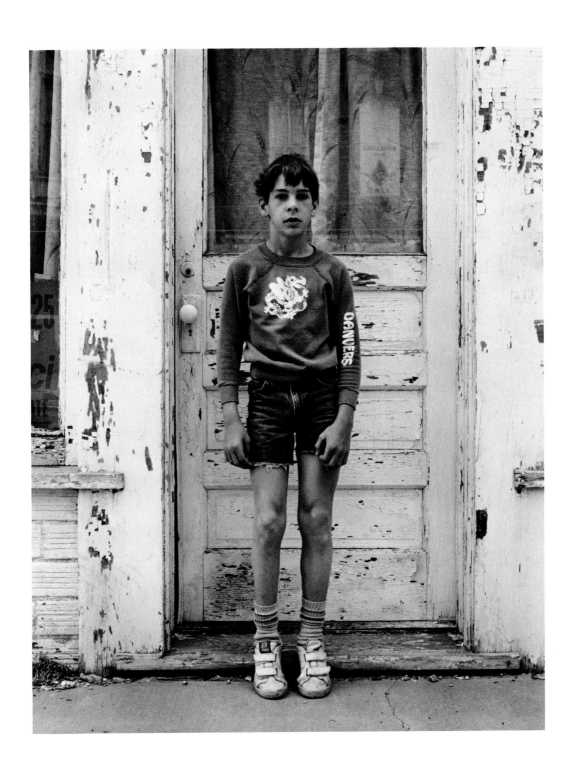

Jeremy Rich, Mike Renfro, Waynesville

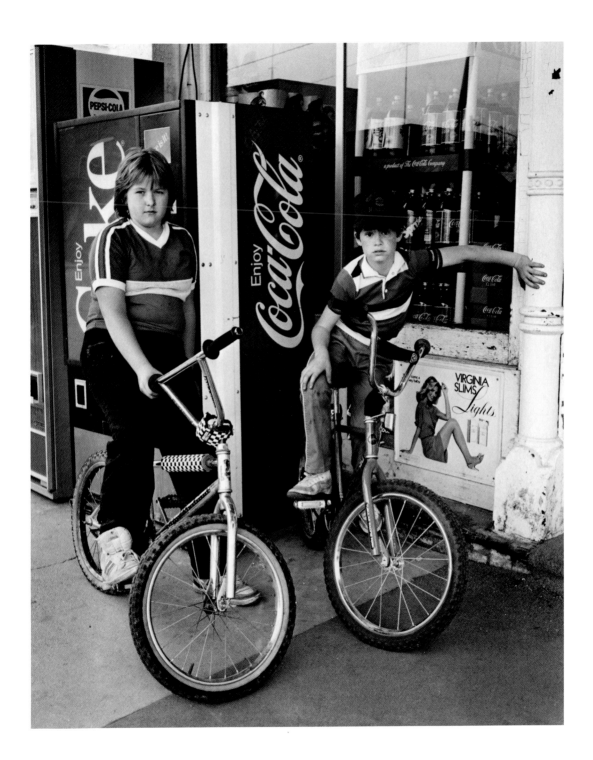

83 | Jason Smith, Tommy Winters, Waynesville

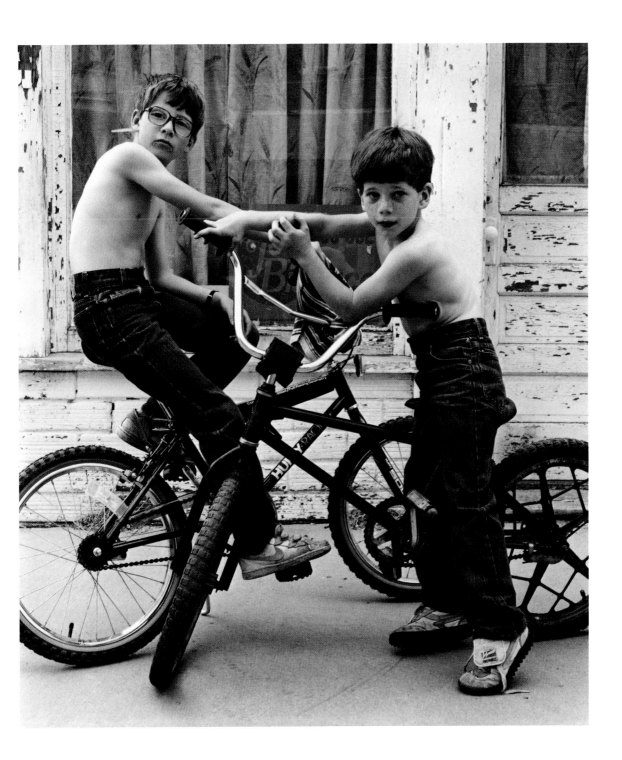

Christi Baker, Hardware Store Clerk, Weldon

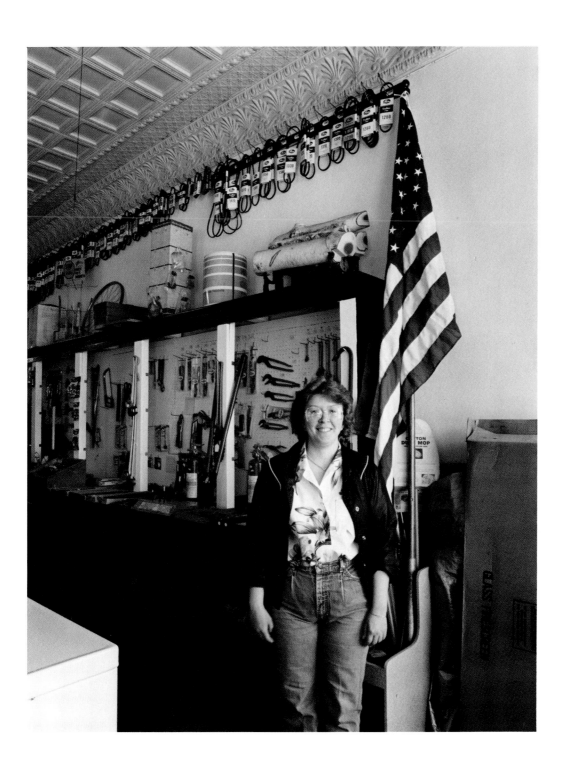

Stanley Gossett, Woodland

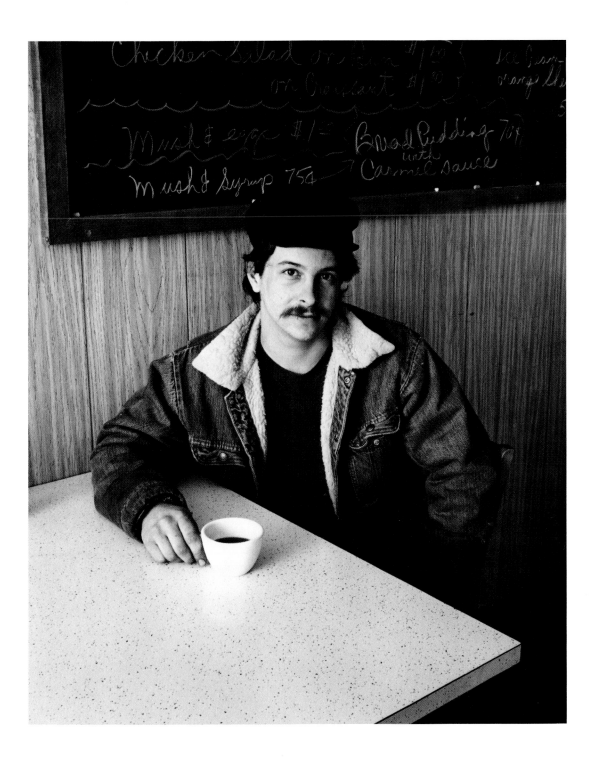

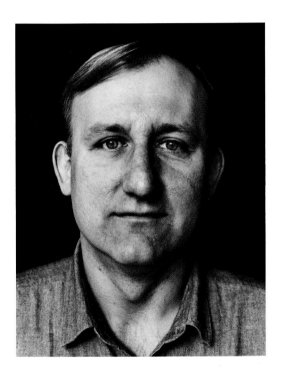

RAYMOND BIAL, library director at Parkland College in Champaign, Illinois, is co-author of *First Frost* and co-editor of *Upon a Quiet Landscape: The Photographs of Frank Sadorus*. His own photographs have been collected in *Ivesdale: A Photographic Essay, Common Ground: Photographs of Rural and Small Town Life, In All My Years,* and *There Is a Season.*